# VERA'S ROOM

## THE ART OF MARIA CHEVSKA

Black Dog Publishing

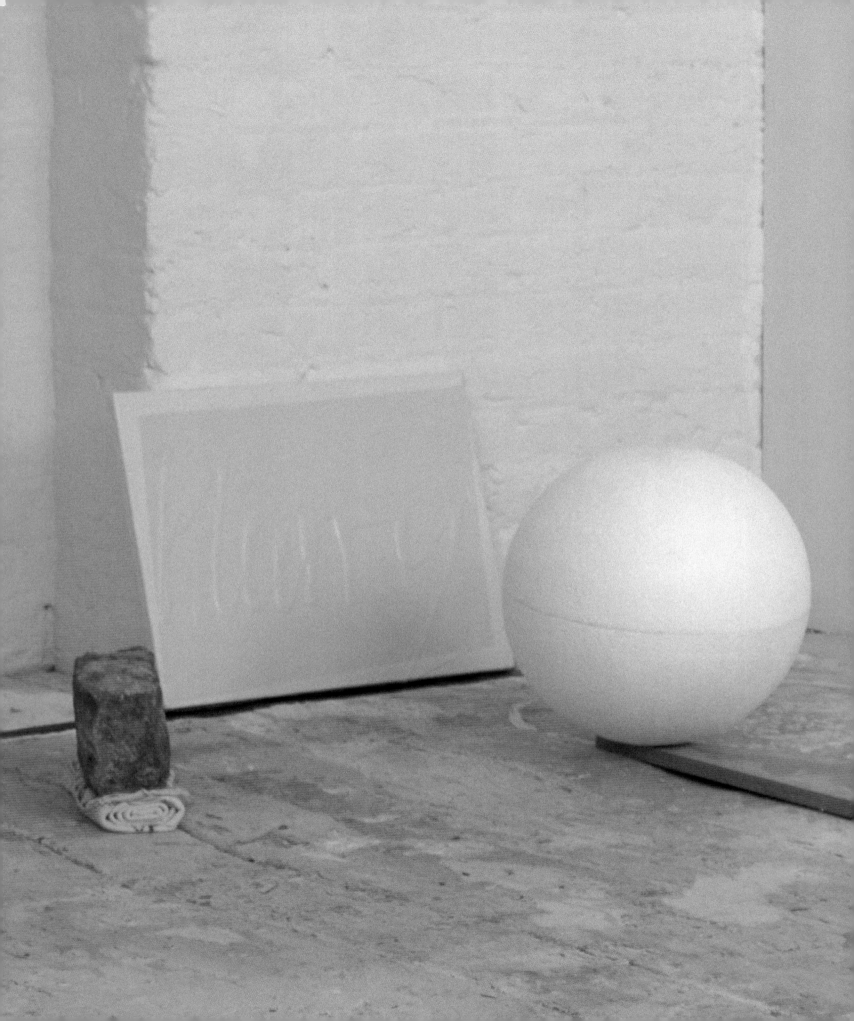

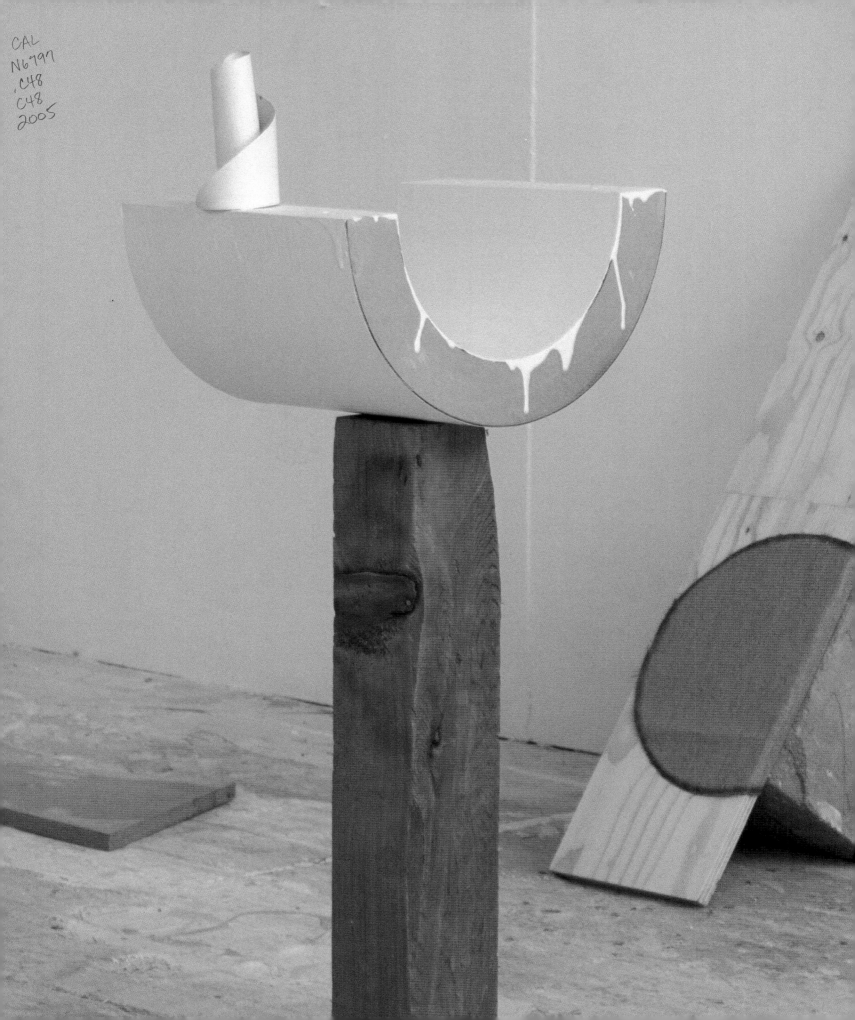

6    PAINTING AS SÉANCE
THE RECENT WORK OF MARIA CHEVSKA
TONY GODFREY

17    SELECTED WORKS
19    IDYLL, 2005
27    ROSA, VLADIMIR, VLADIMIR, EL, KURT,
MARCEL, FRANZ, 2005
39    BUT COULD YOU, 2004-2005
49    CAN'T WAIT [LETTERS RL], 2003-2004
57    ARE YOU STILL, 2002
67    VERA'S ROOM, 2000 (ONGOING)

73    K - A NOTEBOOK (VERA'S ROOM)
HÉLÈNE CIXOUS
TRANSLATED BY SUSAN SELLERS

131    COMPANY, 1999
137    PERPETUA, 1994
143    WEIGHT, 1992
151    VISIBILITY, 1992

156 BIOGRAPHY

# PAINTING AS SÉANCE
# THE RECENT WORK OF MARIA CHEVSKA

## TONY GODFREY

Maria Chevska's works are about collapsing the past into the present, about letting the body spread out into the world, about collapsing the world into the mind. Let me start to explain and justify this apparently extravagant claim by firstly pointing out the obvious paradox: this is a painter whose recent works seem to be quite clearly not paintings at all but sculptures. However, I would contend, they are still paintings: they have evolved from paintings and retain much of their feel. In this essay I want to consider how painting appears in her work in the guise of other media such as collage, words, installation and performance. Finally, as I shall show, it appears in the more philosophical guise of making and thinking.

Secondly, one should point out that the unprecedented range of references can appear hermetic but is presented in a most matter of fact way: "Want it now" written out in large letters, "Don't get annoyed"; or those very simple objects that connect us to the physical world—chairs, belts, bicycles. Here, a rose is a rose is a rose and therefore seems to mean more.

Her work in the 1980s was allusive and highly lyrical, and most definitely painting. Indeed, at the start of that decade it was a painting strongly rooted in figurative drawing. The very first object she made (in about 1987) was a wing constructed with fabric. One could relate this to some of the sculptures made by painters in the 80s (Baselitz, Kiefer, Schnabel). It was a way of concretising, making more vivid an image or motif.[1] But where those painter-sculptors tended to make large, grandiose and heavy objects, hers was small, modest and seemingly fragile. Where they used the materials of the monument, bronze or wood; she used the materials of the model maker, fabric and plaster. The comparison with Kiefer's sculptures of wings is instructive: whereas his were vast contraptions of lead, hers was small. Hers suggested nothing but the wing of a medium sized bird, his that of an eagle or a jet bomber. But both are fragments (and as such claiming a lineage not only with Rodin but with Hölderlin) and both evoke flight—physical, spiritual and most importantly imaginative. Kiefer's material (as heavy as lead) clearly carries its own blatant hubris with it; Chevska's is more clearly an emblem of optimism.

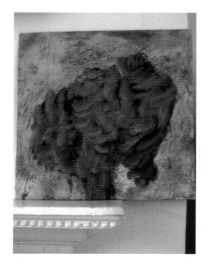

Maria Chevska,
untitled, 1988,
oil on canvas.
Courtesy of the artist.

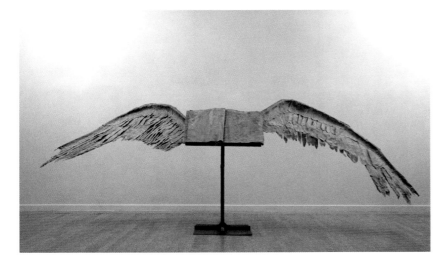

Anselm Kiefer,
*Book with Wings*, 1992-94.
Collection of the Modern Art
Museum of Forth Worth,
museum purchase,
Sid W Richardson Foundation
Endowment Fund.
© Anselm Kiefer.

Her work since then has regularly included objects: for example in 1990 a lamb skin was hung as a de facto painting in a five part polyptych *Safe*. Visually it was not radically unlike a painting, it was approximately rectangular, it hugged the wall, but it was a found object. It was a different material: it had connotations of softness—this is what many new born babies lay on—and connotations of warmth and nurturing.[2] The association of a skin (this is a hide) is not unlike we have with canvas, but it bore a trail of very different associations. She saw it as looking in shape and material as a painting that was turning into an object. In that she was transforming a horizontal surface into the vertical plane one could make comparison with Daniel Spoerri and his Tableaux Piège (Trap Pictures) in which he fixed and hung vertically the tables at which he and friends had eaten, replete with used plates, ashtrays etc.. By so doing he was fixing in aspic, as it were, an anecdote, but Chevska is fixing something far more abstracted or open ended. What these artists do share is a delight in the incongruous treated as if it were normal, the comic play of acting as if something is not out of place—something that was always implicit with Duchamp and his play of the readymade.[3]

Her paintings of the 1990s would often have several elements: areas of pure saturated pigments, depictions of fragments of the human body and tokens of reality: ECM charts. A small diptych of the period was typical in putting a canvas with a pair of lips painted on a large scale next to a monochrome panel richly loaded with pigment—the most sensitive part of the human body next to painting at its most succulently material. Her work was always exceedingly elegant holding these disparate objects together formally. This allows the viewer to enter into a conversation with the various parts (or actors), questioning and thinking about what they could variously signify.

The first real objects that she made were, she remarks, like kaolin prosthetics, bandages that had been moulded into living things.[4] They were small, fragile and hollow like theatre props.[5] (This sense of emptiness pervades much of her work: a painting, again she remarks, is formed of a crust.) Her work has long forsaken figuration (the cloth with the bird embroidered in garish colours now hung on a chair rung in *But Could You*, is the first figurative motif she has used for several years) but the implicit presence of the body in such images as these is important.

What is the difference between this use of fragments and the use of collage in classic modernism? One of the key moments of modernism was when Braque and Picasso introduce fragments of the real world, scraps of newspaper and ink, into their *papier collés* and paintings.

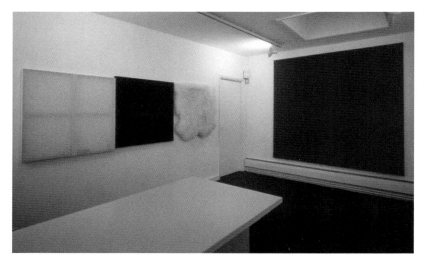

Maria Chevska,
*Safe*, 1992,
mixed media.
Courtesy of Anderson O'Day.

How different is the chair in *Can't Wait*, 2003-4, to one of those scraps of paper? From the start the fragments in Chevska are larger, autonomous, more explicitly synecdoche. The object is itself untransformed: she does not try to turn the bicycle into a bull.

This apparent connection to that earlier period of modernism is not fortuitous because Chevska wants to appeal to that high seriousness (moral and intellectual) of early modernism. These fragments stand for ghosts: the shape of Tatlin's *Monument to the Third International* is a way of calling up Tatlin himself and all the other artists of the Great Experiment.[6] This is key, as we shall see, to the performative element of the paintings: these fragments are props for the enunciation of that past time, conduits through which can come the sense of urgency and aspiration of those long dead people.

However, we should not see these elements as melancholic or nostalgic reminders of a past, long gone world, rather we should take them as tokens of a continuing presence. Nostalgia is about irremeable loss. Early modernism was not proclaiming a tragic but rather a comic vision of the world—a world that was always filled with the potential for, in WB Yeats' sense, gaiety.[7]

Those classic shapes of early modernism: the triangle, the square and the circle recur here as three-dimensional objects as if they were ideal forms. They are long distant relatives of the shapes in Dürer's *Melancholia* or all those seventeenth century prints where artists tried to work out the truth of perspective and proportion, using them as if basic geometric shapes were the very tokens of rationalism. What can shapes mean? Is the black triangle laid out on the floor connected by a line to the wall then a flag on a pole? A standard raised for utopian modernism or, if we recall the colour, for that other utopian dream, for anarchism? Chevska herself cannot *not* be reminded of the multiple made by Beuys where a triangular flag was attached to a toy train.

The objects may be like bleached shadows from Plato's caves but they are always in a sense humdrum, everyday. Most of these objects are things that she finds outside her studio in the unexotic world of Peckham, south London. When we look at the objects their status is in a perpetual wobble between the world of art and the mundane. This oscillation, this uncertainty, this wobble is important in the way it undercuts the understated directness of the 'made' elements. In a sense these fragments act as icons, short cuts (using the sense in which the term means on a computer now): they zip us back and forth from art to the rest of the world. So it is with the chair and every other object in Chevska's installation-paintings.

What are words but complex shapes? The way in which she paints words is formally beautiful, the laying on of paint is lusciously done—at times like that of patisserie icing. In many paintings the words stand out like noodles in a rich sauce, or as if the paint has flooded in and left them stranded like houses after an incursion of the sea: silent, empty and isolated. The words are things, shapes, made with material: liquids that have gone solid.

What easier or more direct way to call forth others, living or dead, than to say their name? The naming of names, the saying of words. The objects are like things with names, but they have none. Since God enlisted Adam to name all the animals of the earth we have always implicitly believed that every object must have a name and that somehow that name is its essence, the handle with which we can hold it in our world.[8] The silence of their namelessness fills the ether around the sibilantly whispered aphorisms. Indeed the words painted here are in counterpoint with the nameless objects as the one with the other.

There is of course a precedent in the naming of names to summon a historical presence in the work of Cy Twombly. Much as Twombly paints the names of Thyrsis, Apollo or Aristaeus to summon them, or writes lines from Chapman's translation of Ovid's account of Hero and Leander to call simultaneously Chapman, Ovid, Hero and Leander to a restaging (in paint only) of the botched lovelorn crossing of the Hellespont, so too Chevska writes words of Kafka. If not to bring them to life again then to whisper their words with an insistence that these are not dead but the words of the still present. Words, names cannot die. Twombly also serves to remind us that calligraphy was once an art form, though his calligraphy is a far more abject and scatological manifestation than any sixteenth or seventeenth century mannerist.[9] Chevska's writing is treated more like physical matter than writerly line.

The 1990 exhibition at Anderson O'Day, London, where she showed the painting *Safe* mentioned above, was also where she presented her first work including words: stitched in white onto large paintings on purple taffeta were the words "lemonade everything was so infinite". These were the last words of Franz Kafka which she had found quoted in a book by Hélène Cixous.

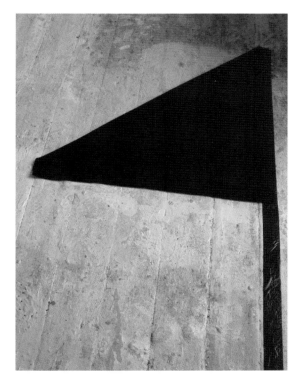

Maria Chevska,
Detail from *Rosa, Vladimir, El, Kurt, Marcel, Franz*, 2005,
felt.
Courtesy of the artist.

It was important from the start that the words had a very physical manifestation, that they should be simple texts but full of potential meanings. At the end of his life, too ill to drink comfortably, Kafka is probably remembering his childhood. The text acts in a circular manner, repeating itself, returning to the past but not alighting there.

*Safe* too had words: stitched in reverse on the central panel of black/brown taffeta was a text from Cixous' 1971 book *Angst*. This text could be read more comfortably on the fifth part of the polyptych—a sheet of paper placed on the table nearby on which the same words were printed.[10]

To write words and to read them is to mouth them: our lips sometimes move as we read. These written words are akin to a whisper—murmurs of unfinished sentences. What they say first is that someone is speaking, secondly that in an understated and unemphatic way, something of consequence is being said—as when in the dark of night one's partner whispers what she or he has been thinking of and trying to say all day. It is an important paradox that though they are presented like slogans these words in fact seem intimate.

Or music that is only played silently as a pianist would finger a tune on a table:

> But could you
> play
> right to the finish
> a nocturne on a drainpipe flute?[11]

This quote is written on a scrap of canvas, a pared down imagist poem or haiku in a recent painting. Words and music remain unplayed and unspoken, but always possible, always immanent. The text, like a musical score waiting on a stand implies, and evokes, a musician. So this: initially we may consider that the "you" refers to us, but swiftly we recognise it calls rather to someone, as it were, off-stage.

Her voice, like a voice in a dream close before the dawn and the hour of waking has become more urgent. In her most recent works the words appear like on a *zettel*: notes scribbled on the studio wall: "write often", "there'll be no fights", "can't describe everything".[12] These notes are, as Chevska has pointed out, from Rosa Luxemburg's letters to her comrade and lover Leo Logisch. Installation art has often been seen as an extension of sculpture: objects moving out into the expanded field. In his introduction to *Installation Art*, Michael Archer makes a well argued claim for installation art being a development out of specifically minimal art—or sculpture.[13] But one could point out how much painting in the 1960s moved to the environmental in scale and ambition, how the desire to space and mood is more normal as an ambition to painting, that there is a real sense in which the drama of depicted action and viewer involvement in the 'great machines' of painters like Poussin or David is the equivalent of installation today. Ilya Kabakov, to pick one major installation artist combining image, text and object, began very much as a painter. One can argue that the birth of painting and the birth of installation art (at least in some proto form) were synonymous: that in the caves of Lascaux and elsewhere early man both painted images one-by-one and covered the walls with paintings so that his whole domestic environment was filled. The walls became a projection of both his body and also a metaphorical simulacrum of the world outside. A world of memories or wish fulfillments: a deer, a captured bison.

From the very beginning painting was a way of transforming a particular space, of turning a cave into a room. The experience of the room has remained crucial to painting ever since. Elaine

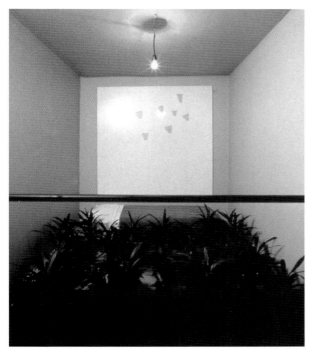

Ilya Kabakov,
*Mental Institution or Institute
of Creative Research*, 1991,
Rooseum, Malmo, Sweden.
Photograph by Jan Engsmar.
Courtesy of Ilya & Emilia
Kabakov and Sean Kelly Gallery.

Scarry has described the room as the most basic and benign refuge likening it to the human body as it offers warmth and protection for the indivudual contained within it:

> But while the room is a magnification of the body, it is simultaneously a miniaturisation
> of the world, of civilisation. Although its walls (…) mimic the body's attempt to secure the
> individual a stable internal space (…) the walls are also (…) independent objects, objects
> which stand apart from and free of the body, objects which realise the human being's
> impulse to project himself out into a space beyond the boundaries of the body in acts of
> making, either physical or verbal, that once multiplied, collected and shared
> are called civilisation.[14]

The room is both a retreat or refuge and a springboard for entering the world beyond—for making it anew. Of no room is this more true than the studio. It is a room of hiding away and making, of shadows and projections.

Perhaps painting began with the evocation of the absent other. In that mythic story of the beginning of painting, so beloved of the neoclassicists, a Corinthian woman traced the shadow of her lover so that when he left she could still remember him. Painting is a way of making memories tangible—that is to say of giving them flesh. This then becomes for others the act of conjuring, creating the image of another in his absence. The room is the place of shadows on the wall. If the objects are shadows, are the images shadows of shadows?

These objects projected out onto the studio floor or wall are not to be seen as 'post-performance objects'—no performance has happened save the making: the performance belongs to the viewer who must take the role, mentally at least, as enactor: either actor or impresario. It would be better to see them as *pre-performance* objects. The stage has been set out for a performance, the seat is there for us, the fragments and texts must be sufficient models to construct

the play, just as a score is for a piece of chamber music. If this be a staging, what props are these and what performance do they support? The physicality of the fragments is key: they are *doing* things. It is as if all the sets on Richard Serra's *Verb List Compilation*, 1967-68, had been given to actors and these props are standing in for the actors: "to roll, to crease, to fold... to flow, to curve, to lift, to inlay, to impress, to fire, to flood (...)".[14] Chevska remarks how for her the chairs and bands around them echo Serra and his vision of the body.

At one level, Chevska's installation is a staging of the body and its activities. In *Can't Wait, 2002-3*, as she remarks, Tatlin's tower gets miniaturised like a toilet roll twisted in the hand. This we can imagine as a simple sensuous gesture. It is redolent of model making *á la Blue Peter*. Imagine different planes co-existing: one where the toilet roll is nothing but that squeezed and bent tube of cardboard; another where it is that original model on the float; another where, completed, it towers over the new town, its elements slowly revolving. It must be emphasised how very material these paintings are, how explicit the act of making is. When things are staged they become something else and stay the same.

When Poussin wanted to show a painting that he had completed and was pleased with, he would, on occasion, sit patrons and fellow intellectuals as in a theatre and unveil the painting as if it were a stage show. We have accounts of viewers describing the action of the painting as if it were a drama unfolding in front of them. Indeed the reading of history paintings—which, we should remember were the great ambition of three and a half centuries of Western painting—was always, in effect, close to the reading of plays. The staging of paintings has long since passed into the hands of curators and gallerists. What Chevska is doing in her shift to installation is to reclaim that possible space where artists, not curators, stage the event. The act of making is intentionally reverberating into the future (which is the present for the viewer) and into the past where dead voices await to be re-awoken. Meaning would always come, she believes, through material and materiality, the text appears through, and only through, this materiality. She adds things to paintings

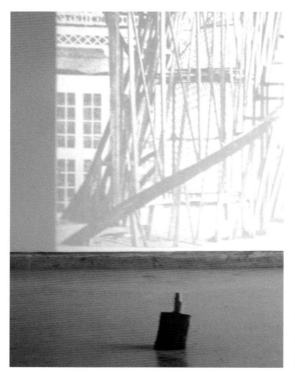

Maria Chevska,
*Untitled*, 2004,
wood paper projection.
Courtesy of Parc St Leger
Centre D'Art Contemporain.

until they are full. She uses blackboard, floor or house paint specifically to emphasise the materiality of her works, to help ensure the text co-exists as another physical element in this reading room. The materiality of the paintings is ever more explicit: the nine foot long white paintings in recent installations such as *Are You Still*, 2002, she sees more like walls than traditional paintings. Paintings can end up as a type of furniture: the big stretcher in *Can't Wait*, 2004, was meant to be a painting but now acts as a frame to the smaller painting behind. Scale is always important: often an instantly recognisable thing such as an Anglepoise lamp is there to ensure everything has a very exact sense of dimension.

Chevska has remarked that "the paintings are always intact because the constellations are mutable". The paintings (or those elements that are quite clearly paintings) are there as touchstones, points of certainty in an unfamiliar room. They do not transform as do the objects attached to them or placed beside them: "it is like a black tulip" she says referring to an object on a black painting–*Rrrevolutionnaire, But Could You*, 2004-05–made by covering an old trouser leg with kaolin. Paintings are always paintings: objects may become their associations or the very action in which they are used: "It is a cobblestone to throw at a police horse."

Though the paintings may act as points of certainty, they themselves are very much in transition: the black painting is made with oil based floor paint, a paint that lets gunk get stuck in the surface–hence the imperfections.

Her work seems static, still, near-monochromatic. But, as one looks closer, every surface is to some extant agitated. Everything is moving. That this apparent stasis is an illusion is clearly keyed by the sudden calls of passionate colour. In *Vera's Room*, for example, there is little colour: white and a little beige and the black of the bicycle. How does this emptying out of colour compare to the famous reduction to white and white alone in the paintings of Robert Ryman? Ryman wanted to concentrate on the painting, lose polychrome colour and reduce drawing to the delineation of the edge only. Chevska wants rather to not reduce but slip to space. Colour is not so much lost as bleached. There is the air of the dream–washed out–in some of her recent work: as though we looked at memories or ghosts of things rather than things themselves. But then comes the occasional shot of colour, always highly charged. Where colour appears it is intense, like a flame in the night or like a bloodstain in the snow, or like the juice of a pomegranate spreading on a white tablecloth. Instead of seeing it as a stage we can see the painting-installations as 'philosophical gymnasiums'. The objects lie around as if waiting to be used.

What does such a philosophical room look like? I mean here not the room of a philosopher but a room to philosophise with. The artist's studio can be the model for this philosophical room: if we think of that whole tradition of paintings of the artist in the studio, he or she is usually shown apparently in the act of painting, but to the viewer they are paused, the paintbrush held still. They are thinking. This is made explicit in the famous photograph of Mark Rothko where he is portrayed sat in the studio armchair, no longer even the pretence of a paintbrush in his hand, lost in thought. The artist's studio becomes a model for the philosophical room, a room that ultimately we can only envisage by closing our eyes.

Or perhaps more poetically and more fruitfully we can see them as a rooms made ready for a séance. This is a séance where the past may meet the present: where Red Rosa encounters El Lissitsky in the red triangle. Where the ghosts can come together and talk. This is where Rosa Luxemburg, El Lissitsky, Vladimir Lenin, Marcel Duchamp and Franz Kafka can meet and mingle and marry (in *Rosa,*

*Vladimir, Vladimir, El, Kurt, Marcel, Franz*, 2005). Sometimes these individuals summon with them whole movements: Suprematicism in all its overreaching ambition is there like a ghost too. Under the words "can't describe everything" we see tilted diagonally a white square of Malevich.

In a set of paintings made in 1998—*Mimic*—she filled large canvases with the stylised hand gestures used by the deaf in sign language to enunciate letters. The slow, coded enunciation of words became symbolic of, or rather a way of staging, the annunciation of presence. The painting-installations of the twenty-first century go beyond: they are silent rooms about the act of speech. They have a historical specificity. They are very much about our sense of loss at the end of the last century. Inevitably given our cultural condition they are paradoxical—at once a homage and an empty room. It is for those who can make something from nothing.

This is where figures from the past can be gathered once more together to hold a symposia. I am reminded of Yeats' poem *All Souls' Night*, 1920, where he summons the ghosts of old dead friends; or of Fuseli's *Self-portrait conversing with John Jakob Bodmer*, 1778-81, where a giant bust of Homer looms up, as though alive again and anxious to speak, between Fuseli and his teacher like a giant summoned from the grave. I am also reminded of Raphael's *School of Athens*, 1510-11, where Plato and Aristotle walk amongst all the philosophers again—or indeed, of Twombly's re-working of that painting.[15]

This is not about identifying with these figures but thinking about them: these were people who inhabited a world of action and without irony. They were not just theorists. These are passionate voices—interacting still with us across time and life. Voices that can come back into the now. The modernist project did not fail, Chevska remarks, because it never truly started. It is not the failure of socialism and anarchism that she laments but rather the failure to ever wholeheartedly embrace their possibilities. Not failed utopias but utopias that were betrayed by so-called pragmatists, bureaucrats and those of bad will and conscience. And that lament is tranformed in her work into positive play: these séances are full of laughter, not tears.

"Where can you go to find non trivial voices, where can you go to add a dimension to current art-thinking?" the artist asked herself. Chevska had to extend the boundaries, formally and semiotically to keep herself involved, interested and a participant rather than a voyeur. This is where painting spreads itself cheerfully in its newly expanded field.

1  Cooke, Lynne, "The Painter-Sculptor in the Twentieth Century" by Lynne Cooke in *In Tandem*, London: Whitechapel Art Gallery, 1986.

2  She first saw one of these lambskins in the writer's flat where we used it to rest our new born baby on. Being not only soft but life supportive: even if the baby rolls over it will not suffocate as the wool is so porous.

3  From *Candide* to *Doctor Who*, putting a thing or person in the wrong time and/or place can act as both source of comedy and a way of making apparent the strangeness of what we take as common place or common sense.

4  This and all following quotes and remarks by Maria Chevska are taken from conversations with the author.

5  Perhaps most especially one thinks of the objects brought out once a year for nativity plays or processions.

6  We may remember Camilla Gray's 1962 book *The Russian Experiment in Art 1863-1922*, which in its exposition of a forgotten group of modernists with a utopian social/political agenda was a great influence on conceptual artists disenchanted with the apolitical formalism of the 1960s.

7  As in his poem *Lapis Lazuli* where:

> All...
> If worthy their prominent part in the play,
> Do not break up their lines to weep,
> They know that Hamlet and Lear are gay;
> Gaiety transforming all that dread.

> from Yeats, WB, *Last poems (1936-1939)*, London: Macmillan, 1968.

8  "And out of the ground the Lord God formed every beast of the field and every fowl of the air; and brought them unto Adam to see what he would call them: and whatsoever Adam called every living creature that was the name thereof. And Adam gave names to all cattle, and to the fowl of the air, and to every beast of the field (...)." (Genesis III, 19-20).

9  Islamic calligraphy is something else. I am referring here to a Western tradition where the ornamentation of the letters is taken to mannerist or baroque excess.

10  The other parts of *Safe* were a stretcher covered with transparent muslin, a microscope slide and a large purple painting hung on the adjacent wall. Clearly, in its dispersal of elements and use of text for the viewer to read him/herself into the work this is painting as installation and very much the progenitor of later works.

11  Mayakovsky, Vladimir, "But Could You?", 1913, in *Mayakovsky*, edited and translated by Herbert Marshall, London: Dobson Books, 1965, p. 96.

12  The term used by Wittgenstein for those scraps of paper on which he wrote down thoughts and questions. The word is used for the title of his last, posthumous book.

13  Archer, Michael, *Installation Art*, London: Thames and Hudson, 1994.

14  Scarry, Elaine, *The Body in Pain: The Making and Unmaking of the World*, Oxford: Oxford University Press, 1985, pp. 38-39.

15  The entire list can be found at http://www.ubu.com/concept/serra_verb.html.

SELECTED WORKS

IDYLL

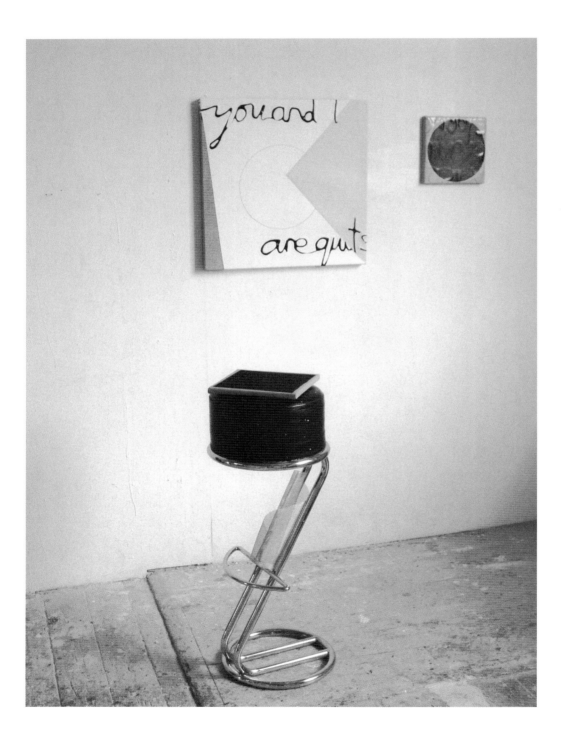

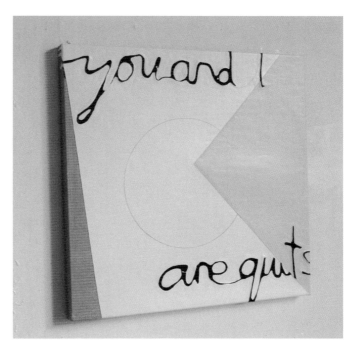

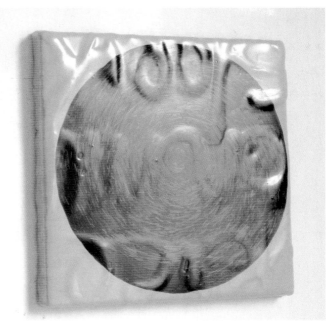

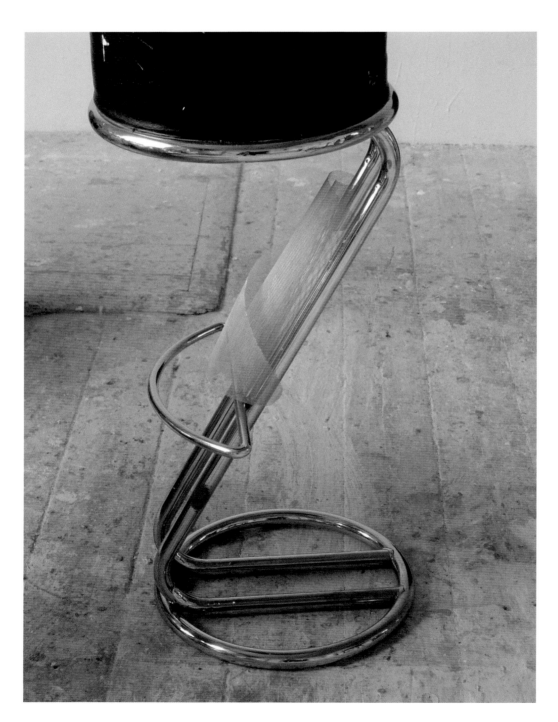

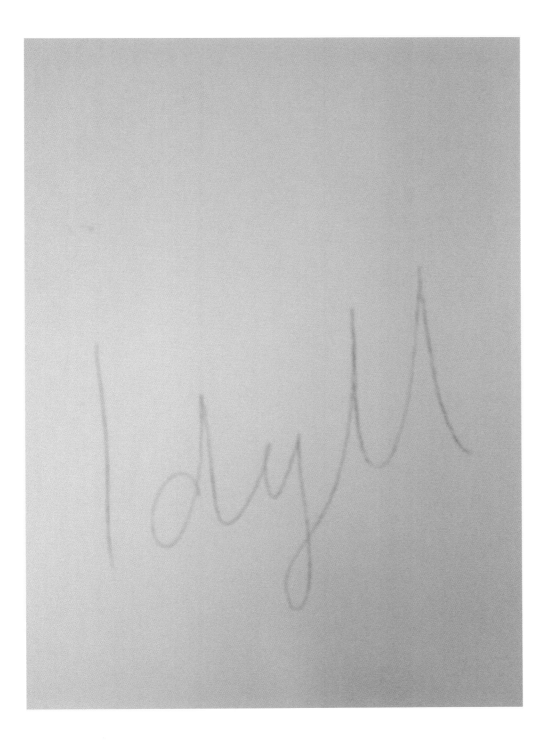

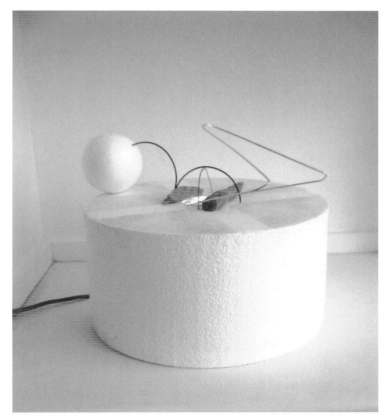

ROSA, VLADIMIR, VLADIMIR, EL, KURT, MARCEL, FRANZ

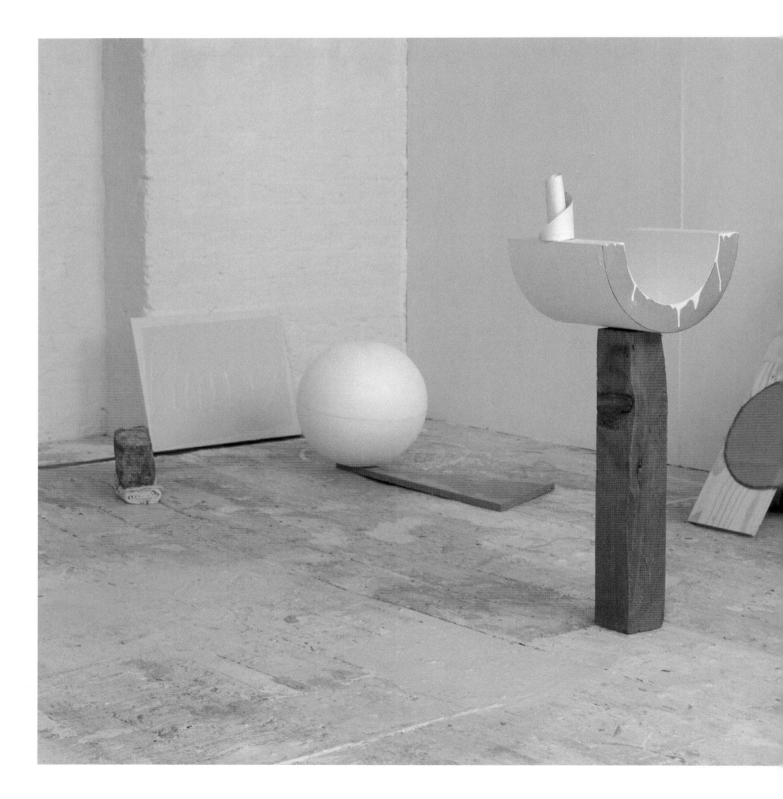

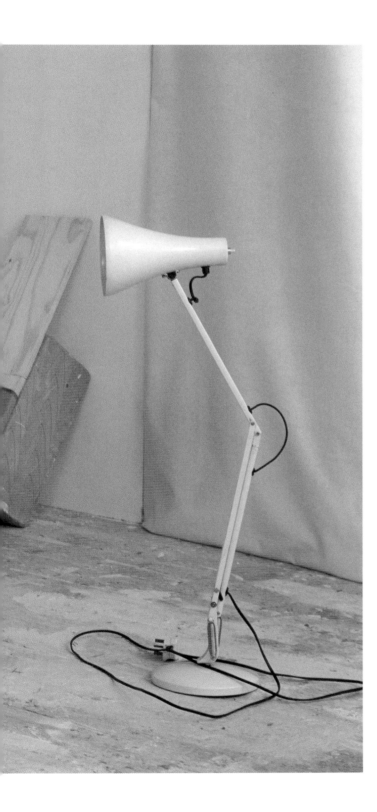

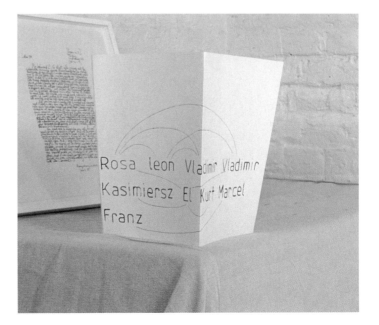

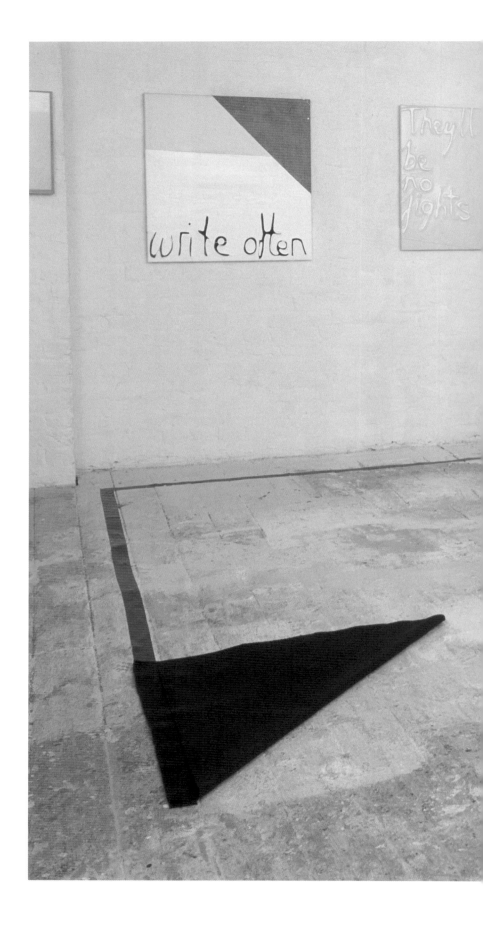

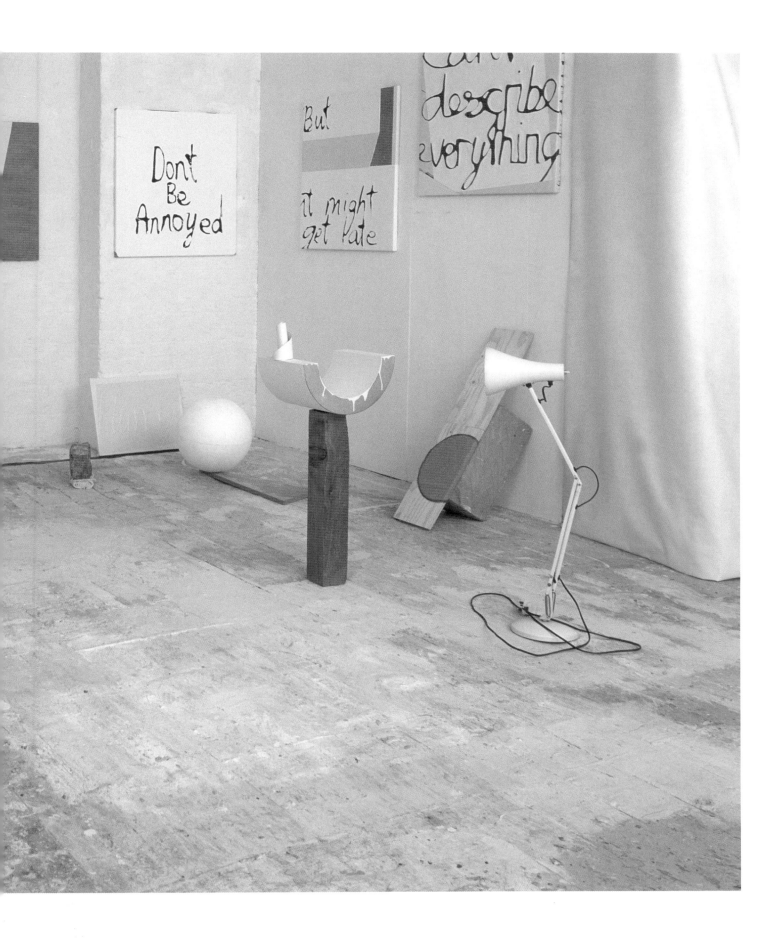

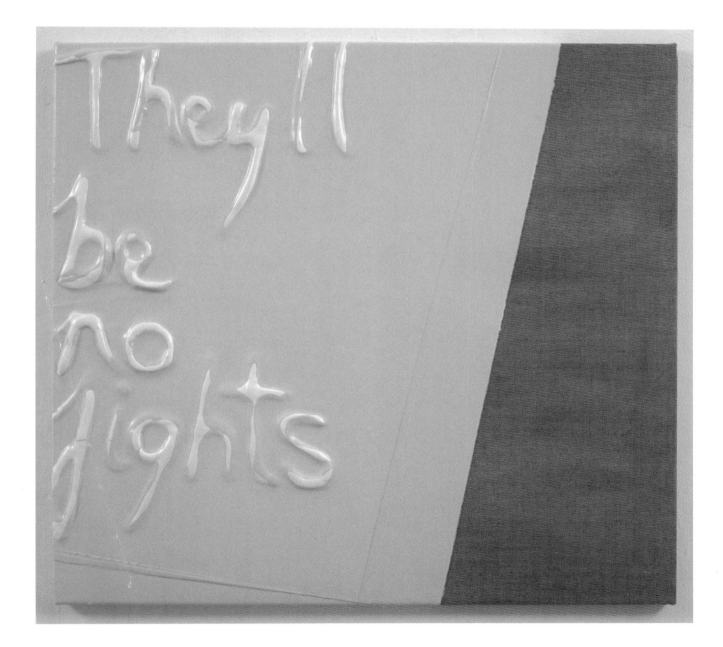

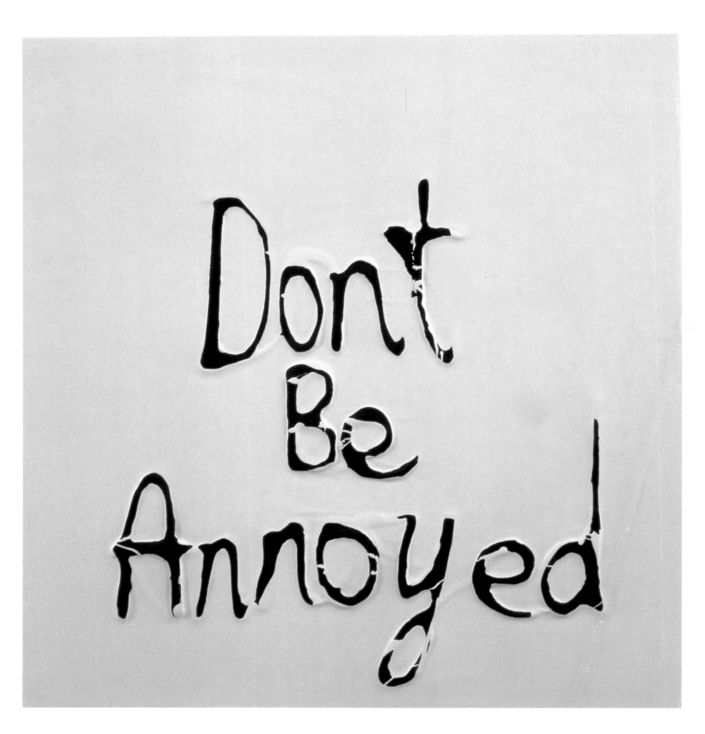

BUT COULD YOU

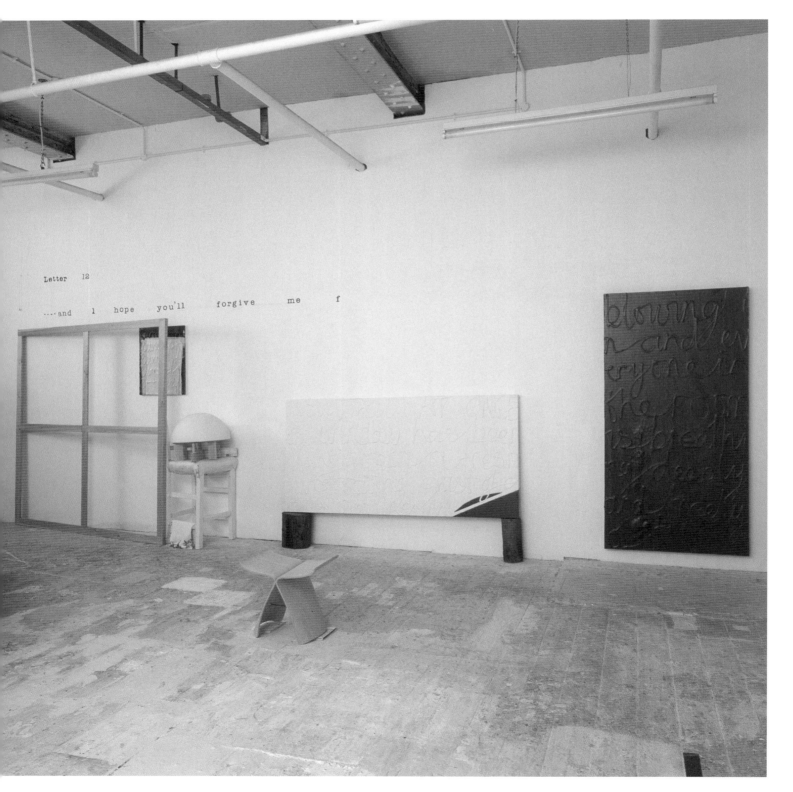

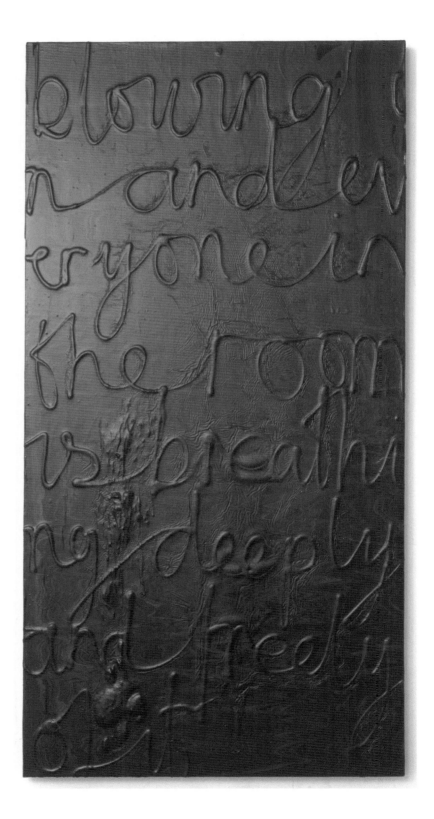

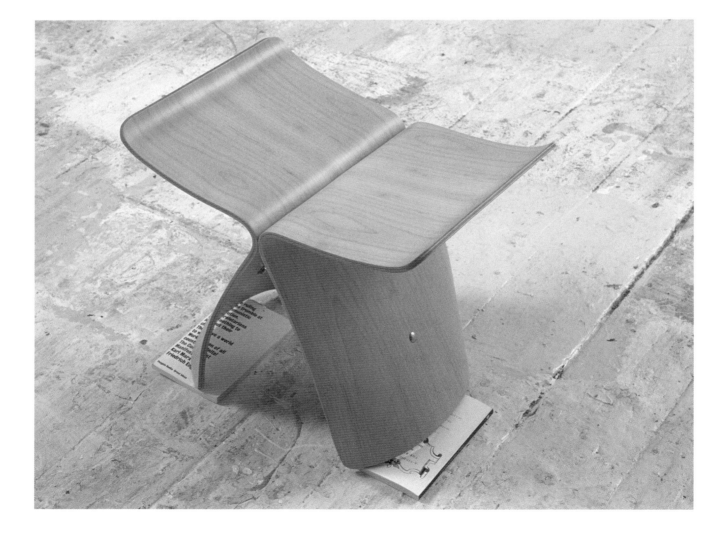

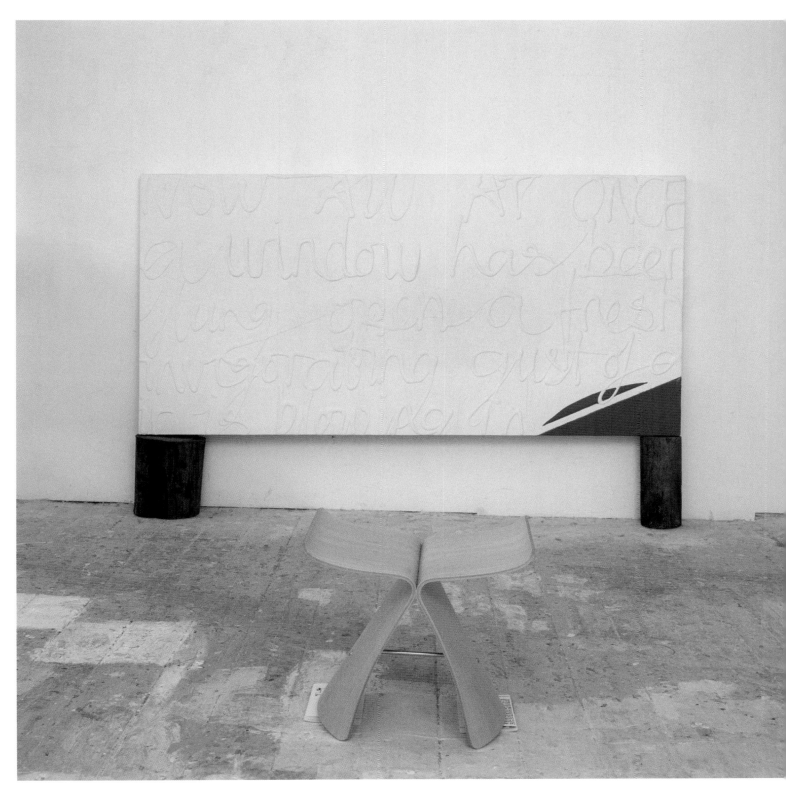

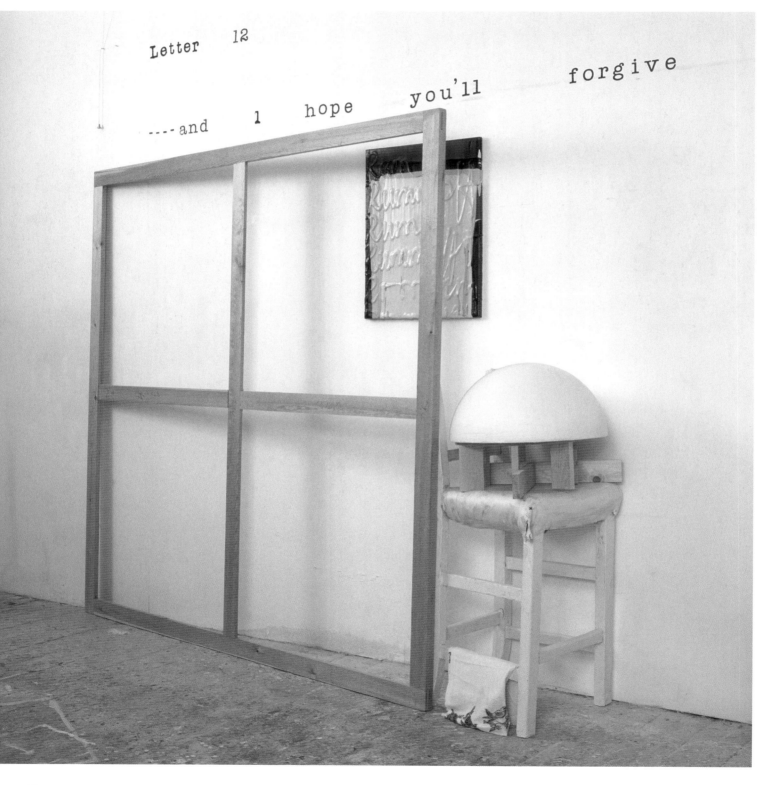

Letter 12

....and 1 hope you'll forgive

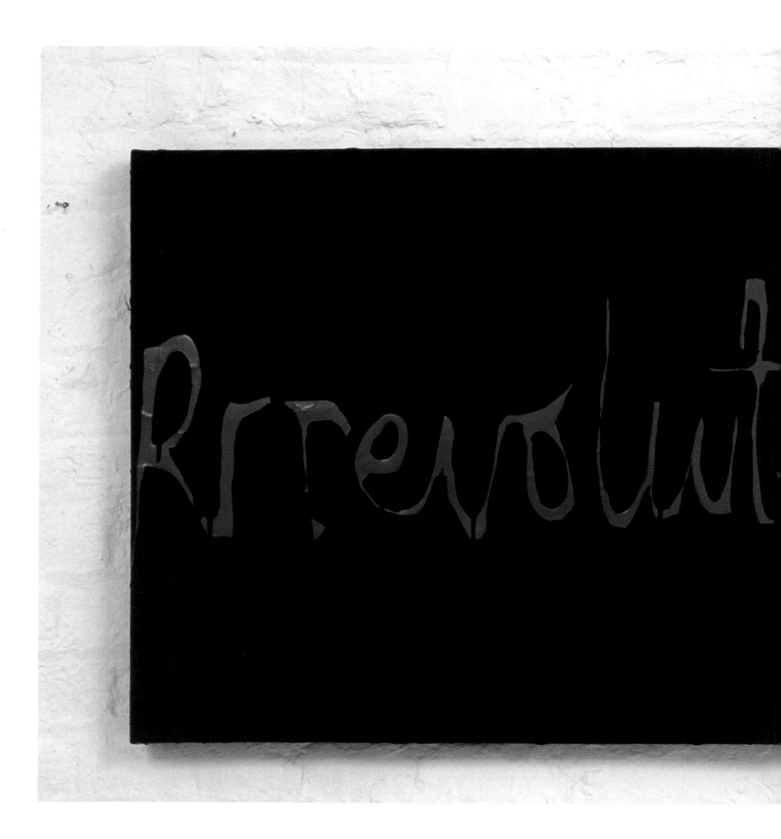

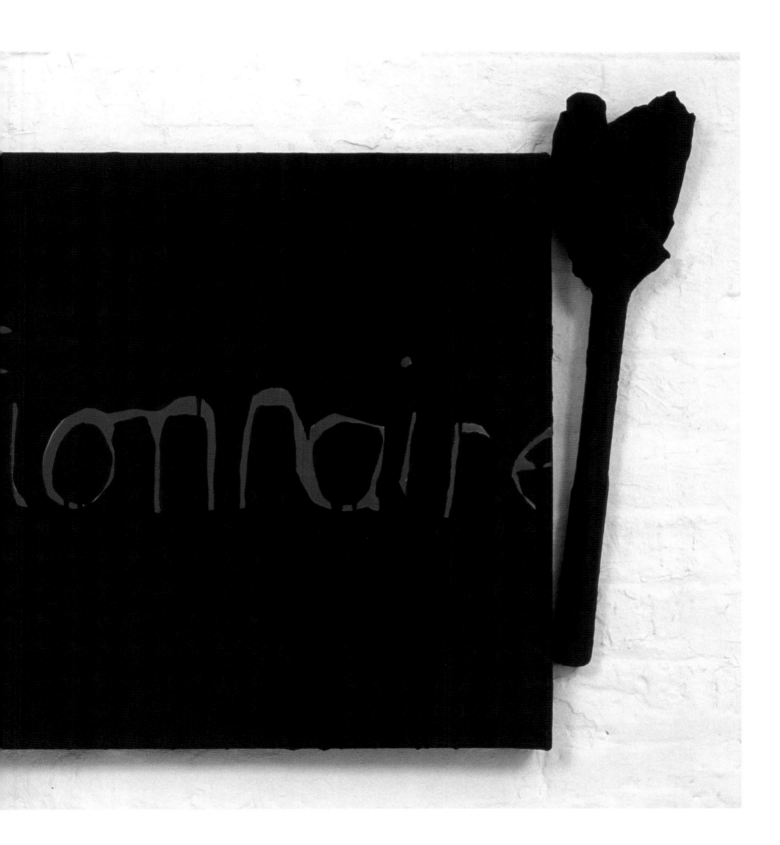

CAN'T WAIT [LETTERS RL]

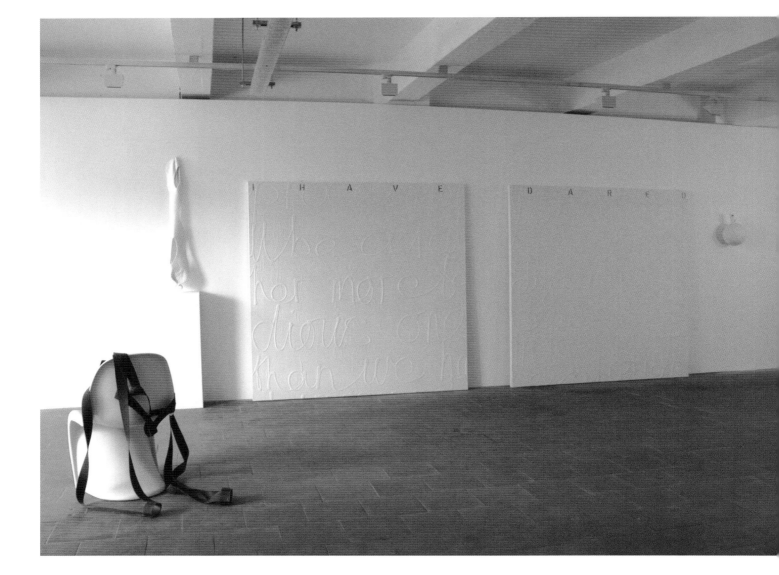

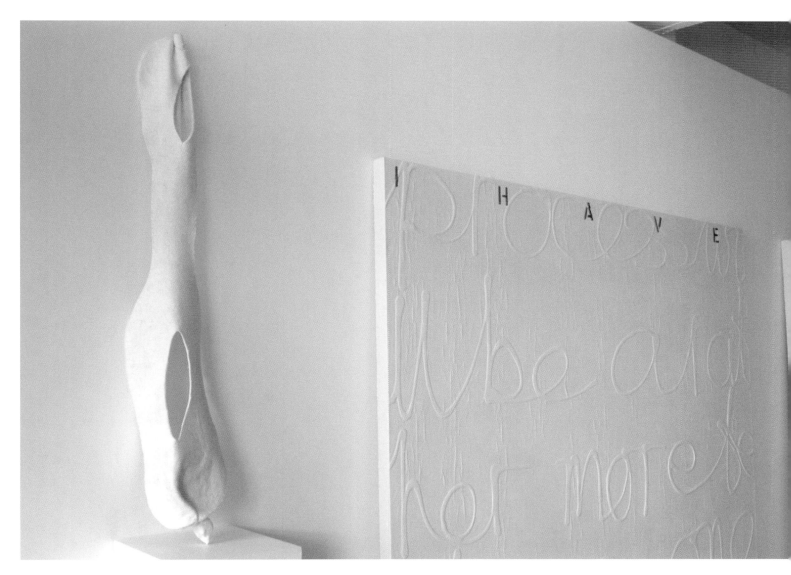

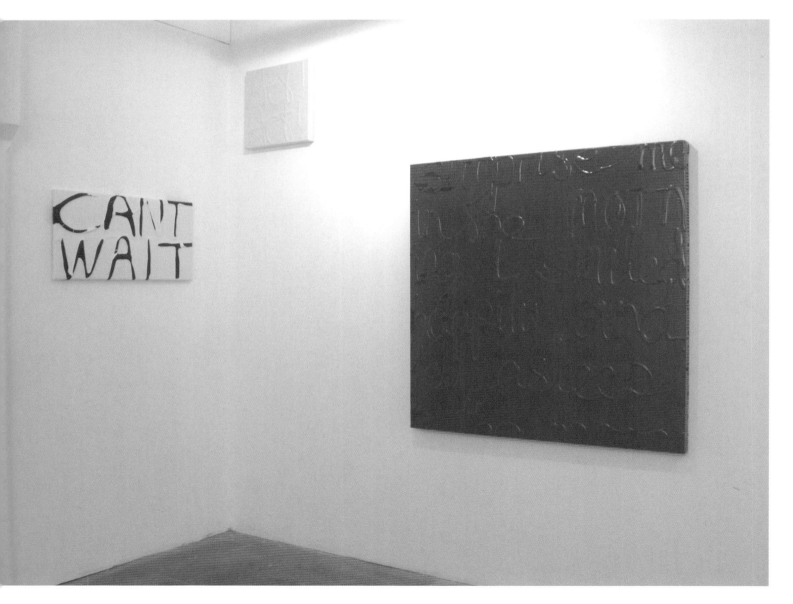

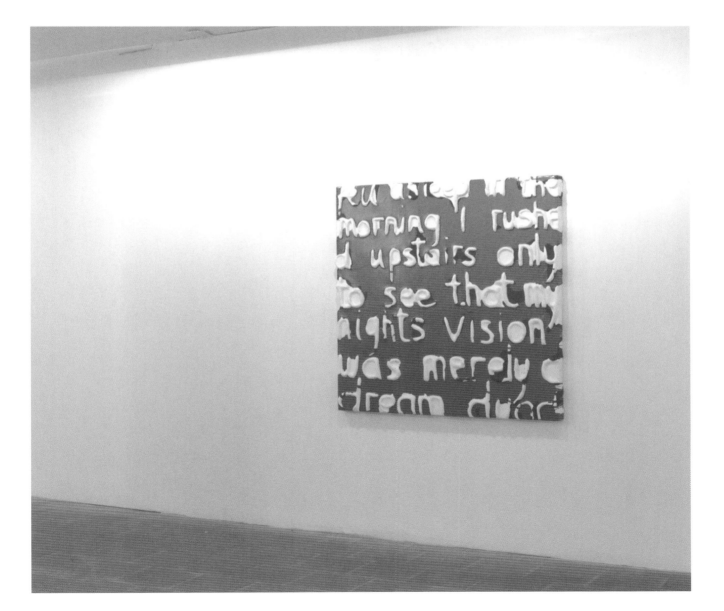

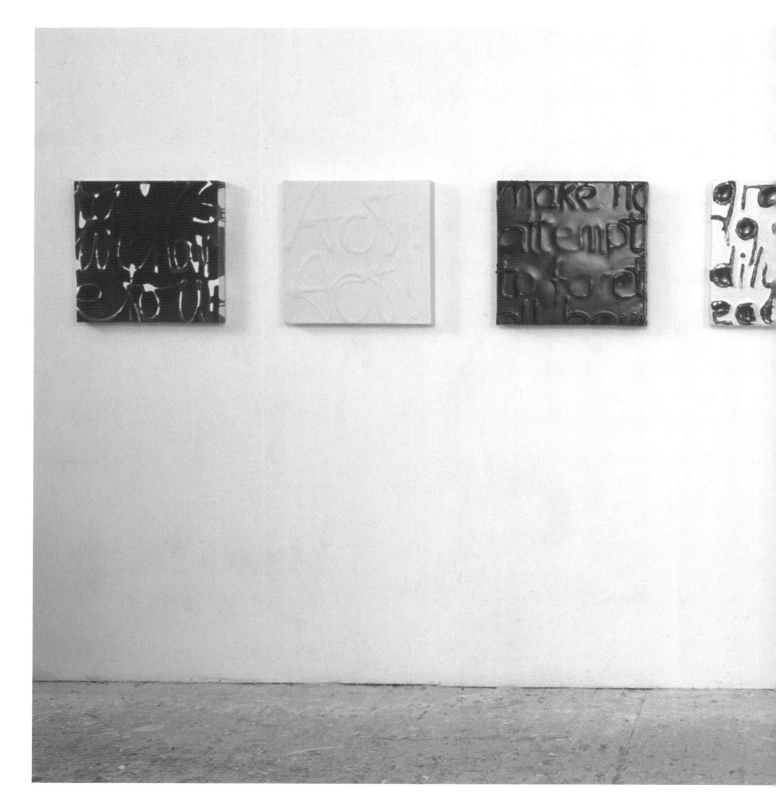

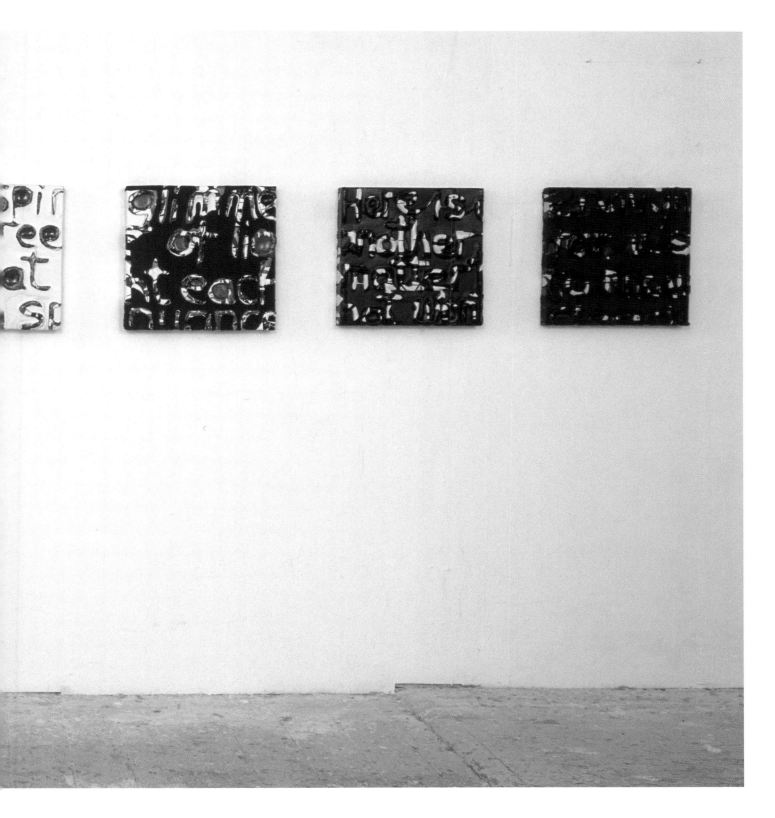

ARE YOU STILL

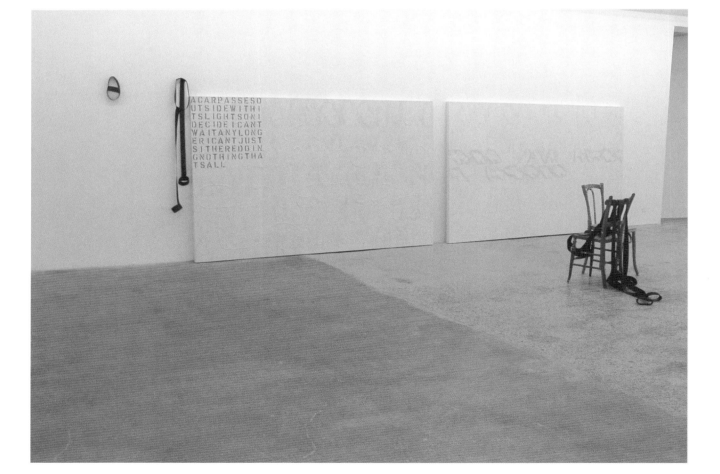

A CAR PASSES O
UTSIDE WITH I
TS LIGHTS ON I
DECIDE I CANT
WAIT ANY LONG
ER I CANT JUST
SIT HERE DOIN
G NOTHING THA
TS ALL

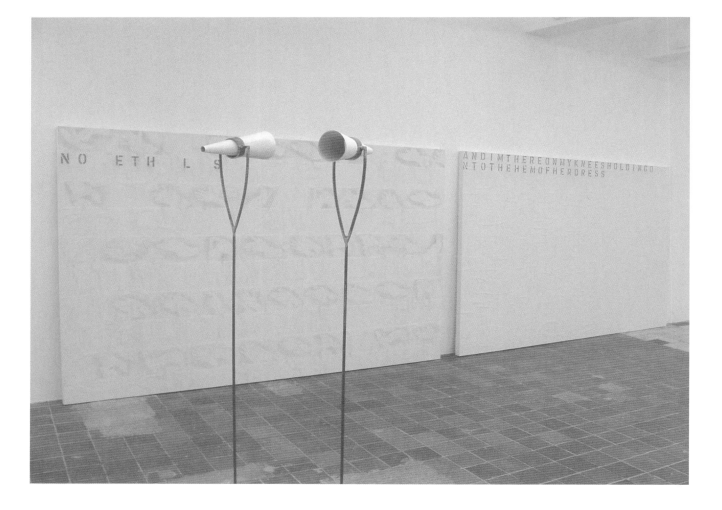

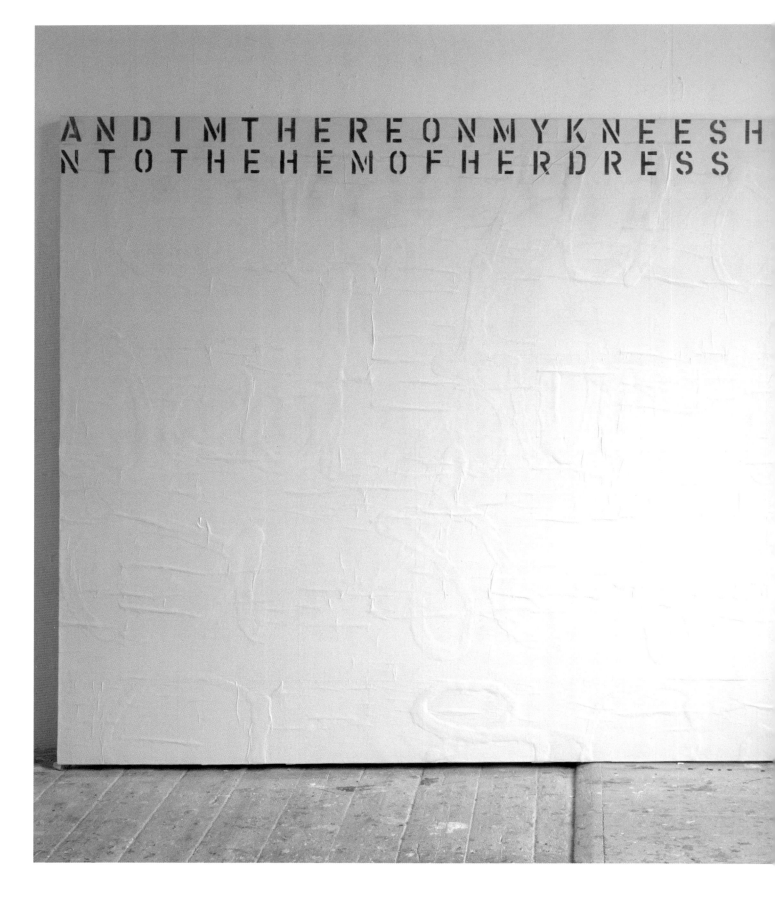

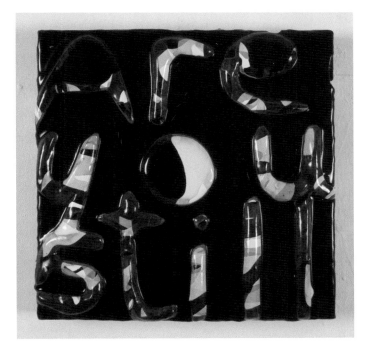

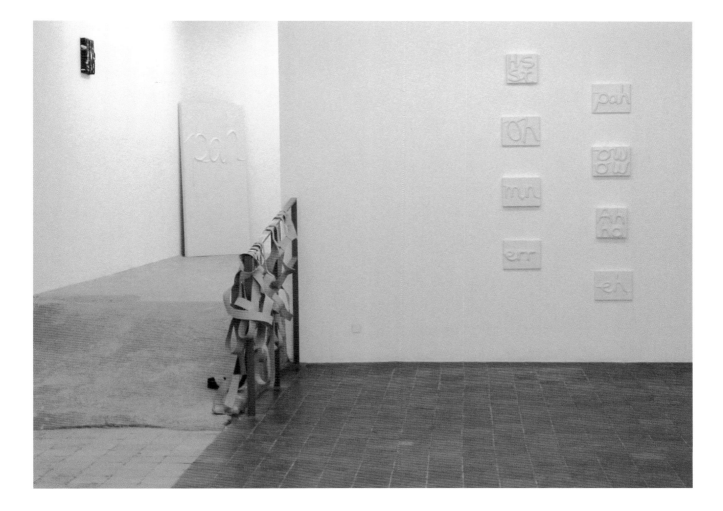

VERA'S ROOM

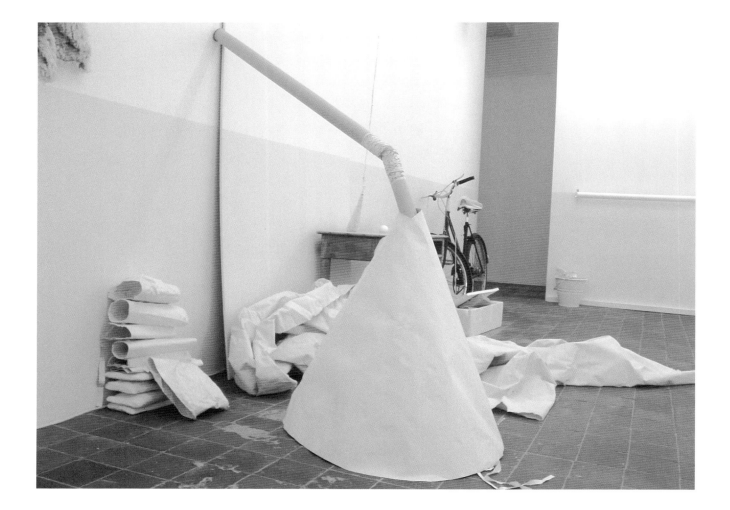

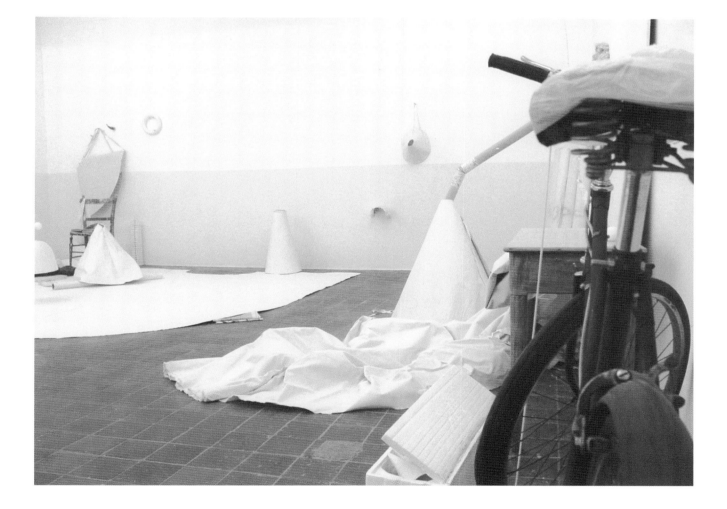

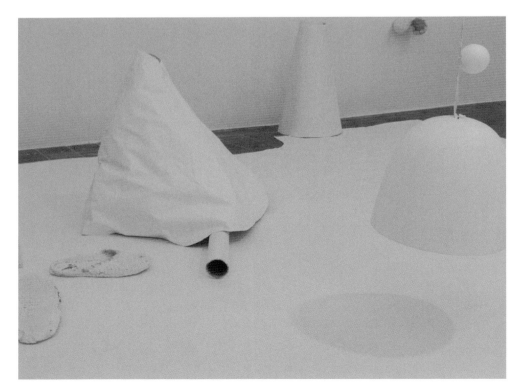

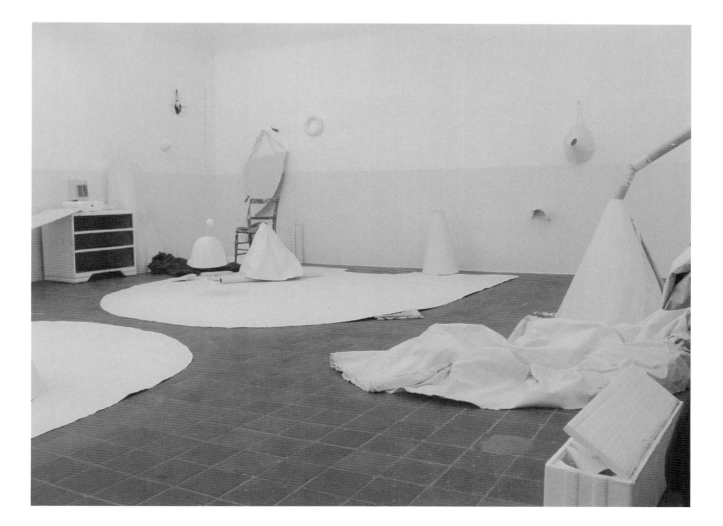

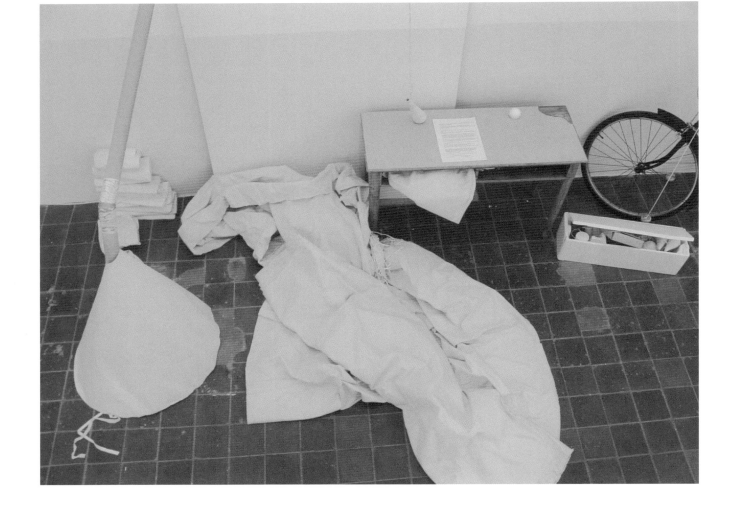

# K - A NOTEBOOK

## HÉLÈNE CIXOUS
## TRANSLATED BY SUSAN SELLERS

**The stuck, left on K of Kasmiach**

Tracks that go towards the horizon
portrait of longing: over there! over there!
form cone the cone thus
of paper or cloth or lampshade recalls

Who's going on a journey? A woman from the back
Is she one? Is she two? Fair dark?

Who's going away from us, who's no more than
a double invisible look and before these unknown
women the canvas palely luminous and without
the edge of the unknown?

Back. Working from the back. They look at the
world and the world's face was a back.

A few black dots on the world's skin: these
are towns.

Seen from very far away.

I close my eyes and I see the furthest-possible
before me: the world
behind me: time

## Immigration act 1971

Refusal of an Entry Clearance
(No right of Appeal)

Who is refused?

The writ of refusal is lying on the side
The refusal, the same one—for decades now
In all languages

Violence of words, spiteful verdicts

The peace of objects
Straight after the refusal, the eviction
2 bowls of milk (2 bowls standing on the side)
As if we should read: cats not permitted
Or No animals admitted

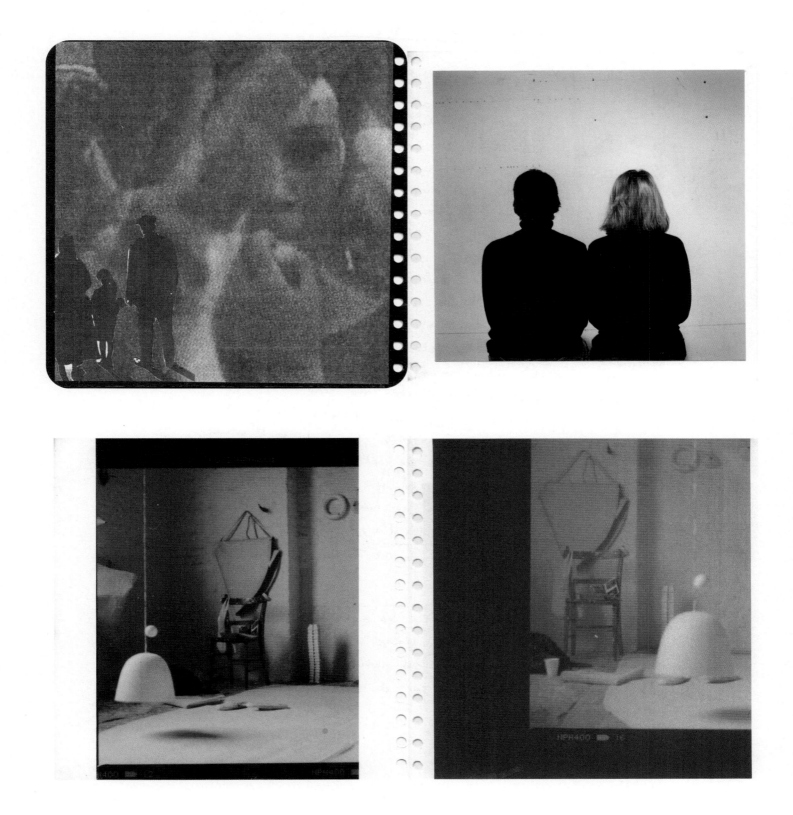

Tissu, issue, tissue, idée

[Ma passion pour les tissus nobles, soies lourdes et musclées du Cambodge, soies arachnéennes de l'Inde, cela s'expliquerait : elles viennent de très loin faire alliance avec mon corps pour créer mes vêtements. C'est une collaboration tissuspétique en soie, qui rêve de luxe, de volupté, de métamorphose

[Mais que dire de ma passion étrange et clandestine pour les tissus de coton domestiques, de mon attirance pour les carrés de cotonnade poreuse tissée large ou cloquée, poro-bref pour les torchons, de préférence de petite taille, pour les essuie-mains nids d'abeilles

[Que dire de la séduction exercée sur moi par ces "choses" sans aucune valeur marchande en apparence, et qui pourtant me semblent si désirables que, plus d'une fois, j'en ai volées, dans un hôtel ou un autre. — Voilà, je viens de l'avouer ici : j'ai été voleuse de petits torchons en coton. [-Et si je l'avoue ici, c'est que c'est par le torchon et le fil de coton que je me suis d'abord liée à mon amie Maria Chevska. Dès que j'ai vu

Où ~~se cache~~ le secret de cet attrait extrême ?

ses installations de fils, ses accrochages de torches de tissus (j'ai reconnu un certain lien très antique, comme les drapeaux, les insignes ou les premiers manuscrits d'un pays ou d'une époque inaugurale

[D'où vient la force de cet attrait extrême ?

[Je feuillette son livre, et ils sont là tout de suite ces froissements de papier jetés de sol, ces linges ces serviettes, ces silhouettes tantôt géantes, tantôt pendues, accrochées, allongées, fuyantes, tantôt volant vers le haut ou vers le bas ou

[ou esquisses d'avions de rêves volant d'ouest en est en longeant le mur renversé d'une chambre.

[Je cherche, je regarde, je suis, je revois. La serviette vire et file un autre cocon. Soudain l'affalement se retourne en vitesse et trajectoire.

[Oui, c'est cela : toute l'inertie et tout le mouvement se rencontrent dans ce morceau d'étoffe qui contient sous sa figure modeste les mille formes virtuelles des objets du monde. De ce chiffon peuvent surgir hommes, femmes, enfants, oiseaux, rideaux, chevelures, ombrelles, mouchoirs, voiles de mariées, nuages, dauphins.

[Il est la peau primordiale sur laquelle le premier des dieux s'est fait la main.

[Il s'est fait la main. Et par la suite il a donné sa main, légué sa main sans fin, sans dehors et sans dedans à la main de tout enfant humain.

[Le morceau de coton que on mélange corps originaire, tapisserie de l'utérus de Dieu, auquel nous nous accrochons pour traverser les tempêtes du temps. Quel est l'enfant qui n'a pas refusé de dormir et de se séparer des bras maternels sans avoir, en échange, le bout de tissu qui raccorde et protège ?

## Enigma of Cloth
Coming from cloth, going to cloth

My passion for noble fabrics, heavy muscular silks from Cambodia, gossamer silks from India, that would explain it: they come from far away to form an alliance with my body so as to create my clothes. It's a clothpoetic collaboration in silk, dreaming of luxury, of voluptuousness, of metamorphoses

But what can I say about my strange and clandestine passion for domestic cotton cloths, for my attraction to squares of large porous cotton or seersucker, in short for dishcloths, preferably small ones, for hand towels in honeycomb stitch.

What can I say about the seduction wrought upon me by these "things" apparently without market value, and which yet seem to me so desirable that, more than once, I've stolen them, from some hotel or other. There, I've just admitted it here: I've been a thief of little cotton cloths.

And if I admit it here, it's because it's through a dishcloth and cotton thread that I first linked up with my friend Maria Chevska. As soon as I saw her installations made up of threads of cloth torches, I recognised a certain very ancient environment, like flags, the insignia or first manuscripts of an inaugural country or time

Where does the force of this extreme attraction come from?

I look through her book, and they are there straight away these paper crumplings, strewn on the floor, these linens these towels, these silhouettes sometimes recumbent, sometimes suspended, hanging, stretched out, fleeting, sometimes flying up to the top or the bottom or

Or sketches of dream planes flying west to east keeping close to the inverted wall of a room.

I search, I look, I follow, I receive. The towel changes and spins another cotton. Suddenly the slide alters speed and path.

Yes, that's it: all the inertia and all the movement meet in this piece of fabric that contains within its modest appearance the thousand virtual forms of the world's objects. From this rag can come men, women, children, birds, drapes, hairstyles, parasols, handkerchiefs, marriage veils, clouds, dolphins.

It's the primordial skin on which the first of the gods practiced his hand.

He practiced his hand. And afterwards he gave a hand, endlessly handed on, with no outside and no inside to the hand of every human child.

The piece of pure or mixed cotton is the remains of the original body, tapestry of God's womb, we cling to in order to cross the tempests of time. Where is the child who has not refused to sleep and part from the maternal arms without having, in exchange, the bit of cloth that connects and protects?

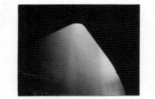

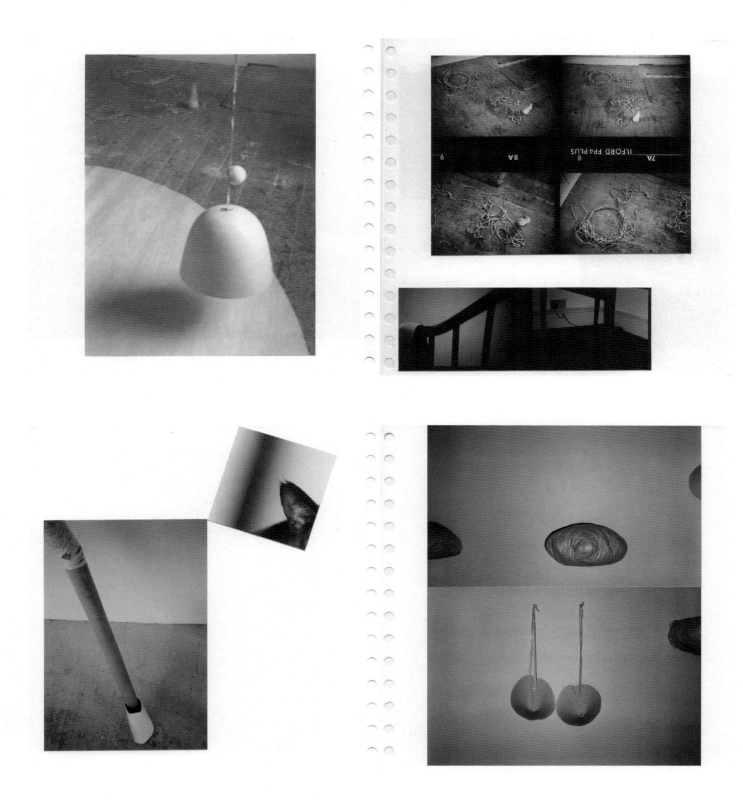

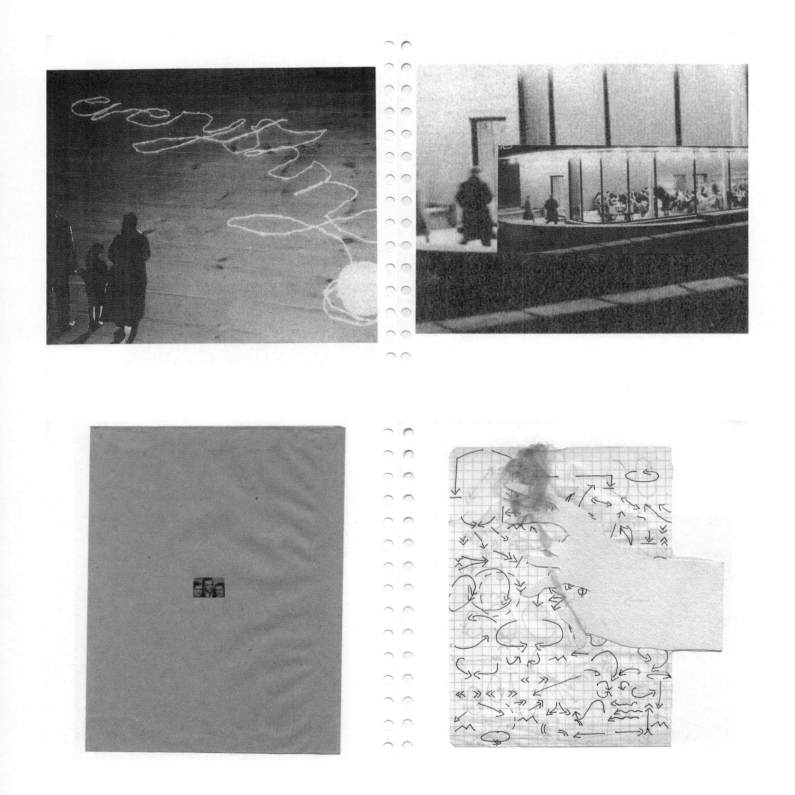

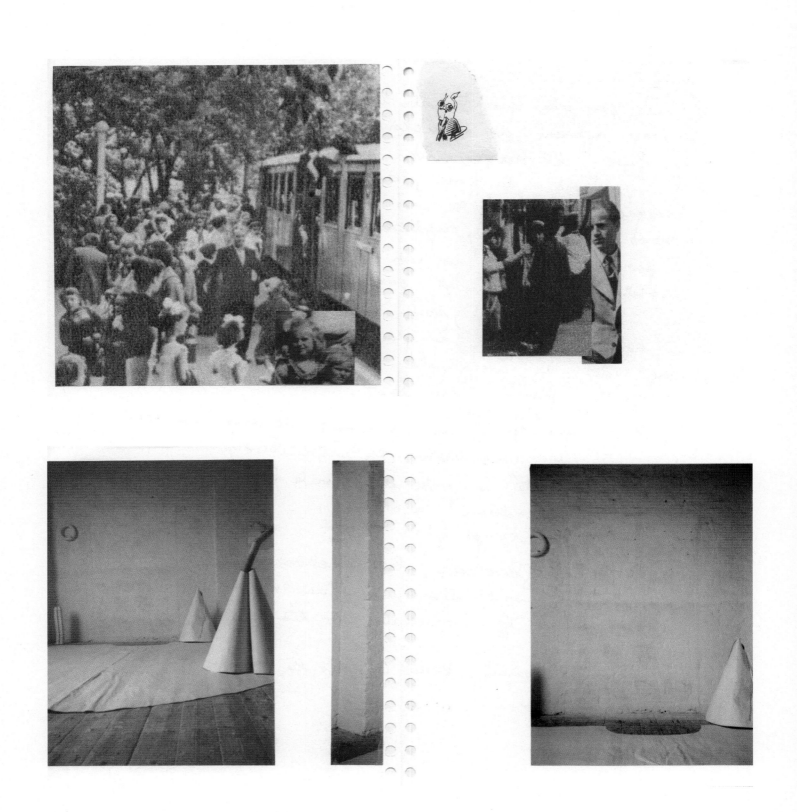

Mouchoir.

[C'est pour cela que tu agites un mouchoir. Détournant
l'usage apparent du mouchoir, réservé au nez, pour
en faire le dernier lien coupé, le signe d'adieu,
le supplément du bras, de la main, du cœur,
lorsque le départ a eu lieu. Il ne reste plus
alors lui et toi, rapetissés par la séparation,
à peine plus gros qu'un coin de mouchoir, détachés,
isolés, le train est parti, le monde est parti,
le mouchoir palpite, seul. Il est griffonné
en haut d'une page à gauche, réduit à
une sorte de hiéroglyphe du regret, minuscule
et faible flamme du deuil.

[Cependant que d'un côté quelqu'un se souvient de vous au bord
du quai et vous dessine en miniature,
de l'autre côté se presse une foule floue, c'était le
printemps, celui qui continue à revenir
une fois le temps fini.

[Des rubans fleurissent les chevelures des fillettes,
les fillettes sont elles-mêmes des rubans,
encore des morceaux de tissu prélevés
sur la vie.

[Comme il faisait beau ce jour-là, dont on ne
sait plus rien.

## Handkerchiefs

That's why you wave a handkerchief. Changing the obvious use of the handkerchief, saved for the nose, and making it the final severed link, the sign of farewell, the extension to the arm, the hand, the heart, once the departure has taken place. Then there only remains him and you, shrunk by separation, hardly bigger than a corner of a handkerchief, detached, isolated, the train has gone, the world has gone, the handkerchief flutters, alone. It is sketched at the top of a page on the left, reduced to a sort of hieroglyph of regret, tiny and feeble flame of the bereavement.

Yet from one side someone remembers you on the edge of the platform and draws you in miniature, from the other side a vague crowd gathers round, it was spring continuing to return once time has gone.

Ribbons flower in young girls' hairstyles, the young girls are themselves ribbons, still bits of cloth taken from life.

How lovely the weather was that day, of which we no longer know anything.

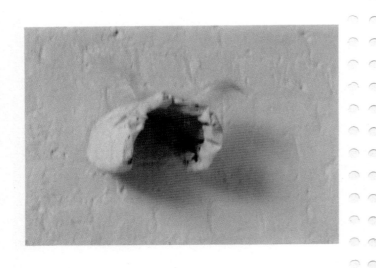

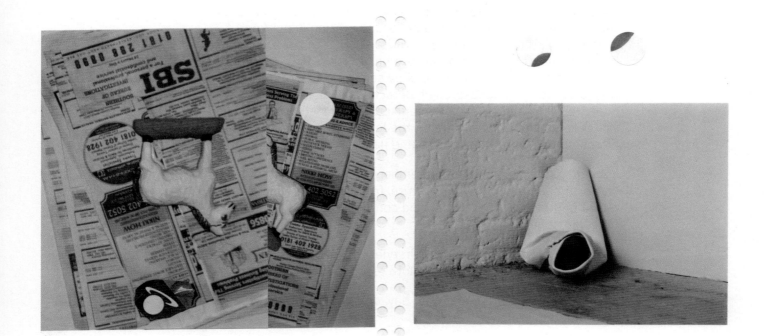

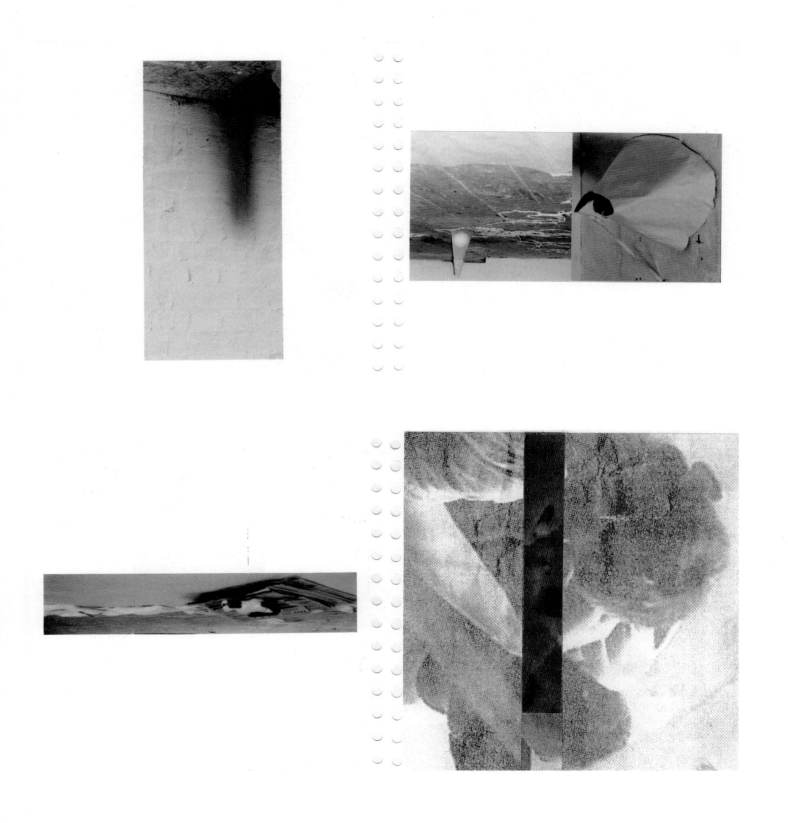

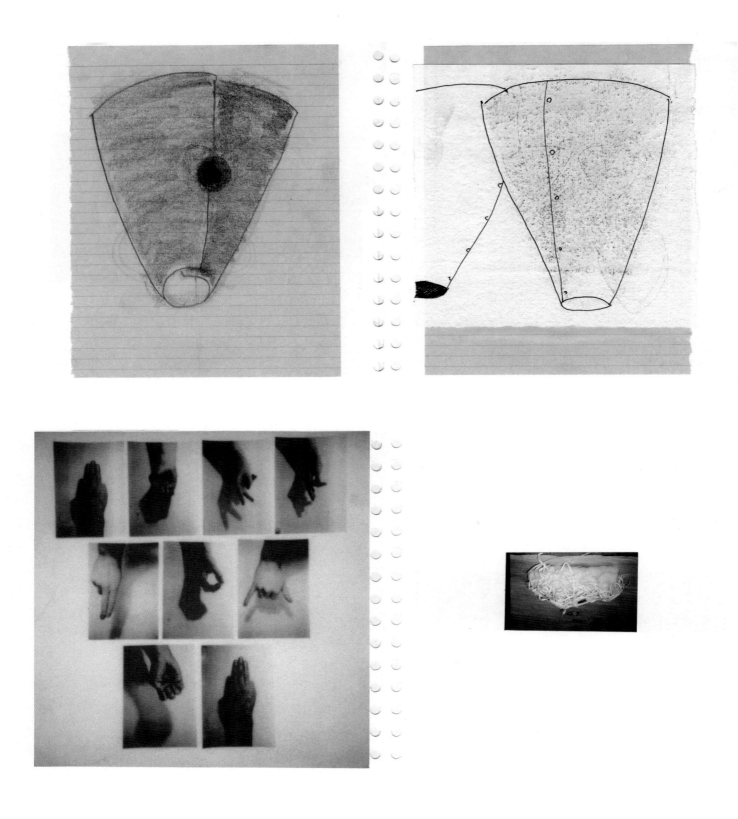

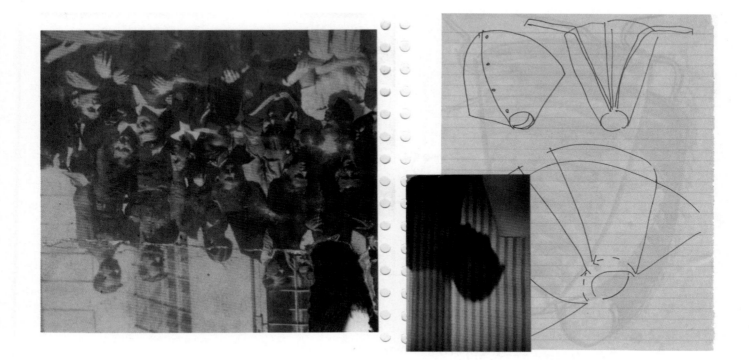

Le livre de Maria,
est-ce un livre ?
Une Promenade ?
Le Tournage distrait d'une rêveur ancienne
Coins de Villes - Une malle pleine de braises, du temps passé :
                                    et Métonymie
Écuelles pleines
    Tout fait        Métaphore        Deux maisons :
                                        Deux écuelles
    Une maison n'est elle pas une écuelle renversée ?

Association     substitution     technique du rêve

Is it book ?   Is it time ?   Où est la scène ?
Sommes nous dedans ?   Sommes nous dehors ?

Maria's book,
is it a book?
A Stroll?
The absent-minded running of an ancient dream
A trunk full of traces, of time past:
Town corners—Brimming bowls
Metaphor and Metonymy
Two houses: Two bowls
Is a house not a bowl turned upside down?
Is it book? Is it time? Where is the stage?
Are we inside? Are we outside?

Le livre de Maria est-il une promenade de spectres ?
Ou le spectre d'une promenade de spectres ? Dans le livre
~~Tous les êtres humains~~ – la scène morcelée du livre,
les êtres humains sont « des éloignés », des imprécis,
des traces. Le monde humain est au passé. Les
draps et les serviettes sont au présent, les
enveloppes sont le présent. Les vies s'effacent
aux fenêtres de rêve.

Je feuillette le livre d'heures d'une voyageuse
qui se souvient des temps où elle n'était pas née,
de la chambre où ~~des~~ des objets attendent que
vienne la maîtresse des lieux avec une patience de chats.

Is Maria's book a strolling of ghosts? Or the ghost of a stroll of ghosts? On the fractured stage of the book, human beings are distant, vague, traces. The human world is in the past. The sheets and towels are in the present. Envelopes are the present. Lives fade at dream windows.

I leaf through the book of hours of a traveller who remembers times when she wasn't born, the room where objects await the arrival of the mistress of the place with a cat's patience.

[Les détails détachés grandissent, prenaeste la synecdoque la
dimension du tout, une pantoufle dit la
femme qui a laissé cette île, cette ville, déserte.
Version moderne de l'empreinte du pied de
Vendredi

[Ceci est un painttext, un pain - text.
~~Anter~~ ~~film~~ [La caméra filme l'état de deuil.
[Il s'agit d'une mosaïque disséminée de souvenirs
mourants. Ils vont expirer. Ils expirent. ~~Ils prend~~
la ~~des~~ caméra filme des restes d'histoires, des
derniers instants de derniers instants.
~~Mais comment expliquer~~
[Une chambre immobile, avec personne dedans.
~~Ainsi~~ La chambre de personne - (32)

The detached details grow, the synecdoche takes the dimension of the whole, a slipper says the woman who left this island, this town, deserted. Modern version of Friday's footprint.

This is a breadtext, a bread-text

The camera films the state of bereavement.

It's a scattered mosaic of dying memories. They are going to expire. They expire. The camera films the remains of stories, the final moments of final moments.

A still room, with no one inside. No one's room.

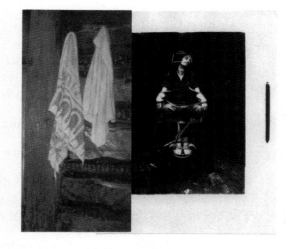

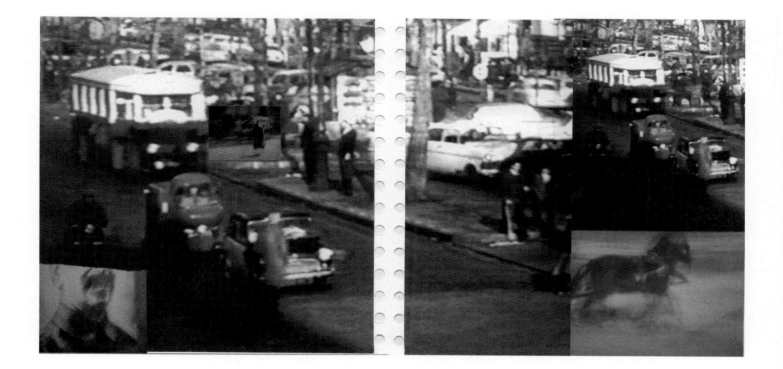

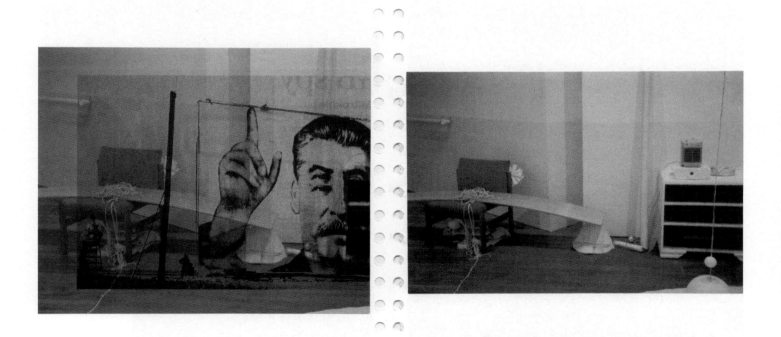

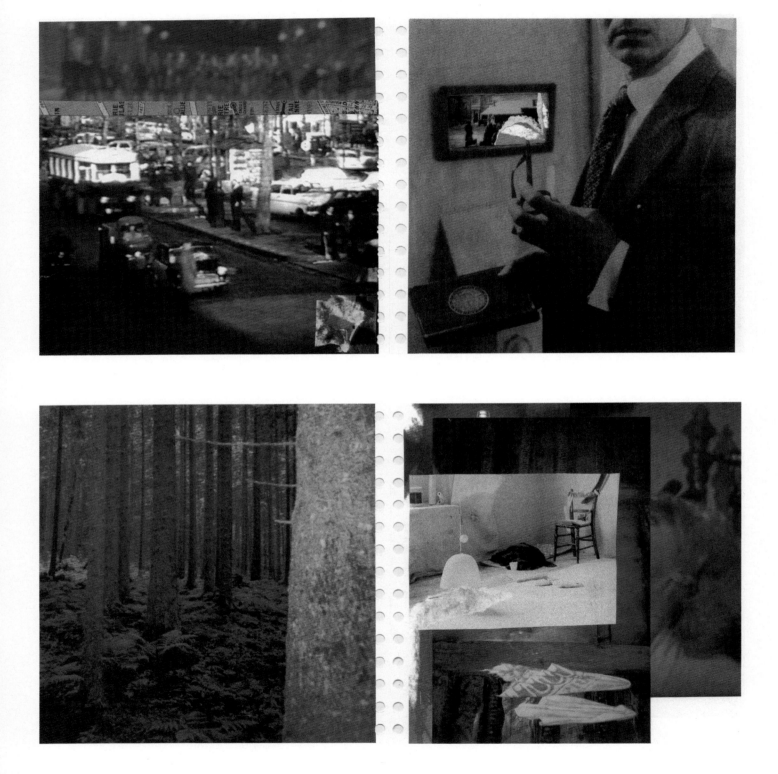

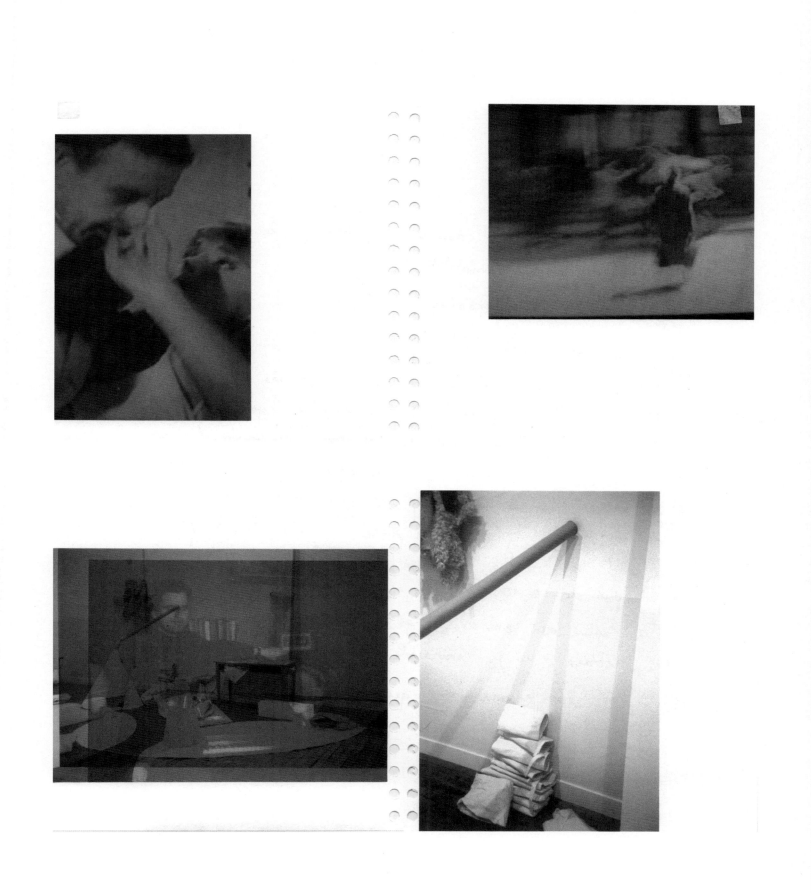

[Une immobilité demeure. Même le mouvement
est frappé d'immobilité (34)

[Qui donc est personne ?

[Qui n'habite pas ici ?

[On dirait le théâtre d'un rêve de K !
De K ? De Kafka ? De Kelqu'un qui a du fuir
soudain. Ou bien qui est devant la porte de la
loi, ou de l'immeuble, ou ~~devant~~ devant la porte
d'un livre ou d'une ville, et qui n'ose pas entrer.
[Mais ----
C'est qu'il n'y a pas de porte. Où est la porte ?
On voit bien des murs, des fenêtres, des sols,
mais pas de porte.

[Toi, qui erres, es-tu dedans ? es-tu dehors ?
Qui étais-tu, invisible sujet de l'énigme ?

[Es-tu la personne a qui l'on a refusé l'entrée ?

Stillness remains. Even the movement is struck by stillness

Who then is no one?

Who doesn't live here?

You'd say the theatre of K's dream. Of K? Of Kafka? Of someone who suddenly had to flee. Or else is in front of the Law's gate, the building, or in front of the gate of a book or town, and who doesn't dare go in. But...

The trouble is there's no door. Where's the door? We see the walls clearly, the windows, the floors, but no door.

You, who wanders, are you inside? are you outside? Who were you, invisible subject of the enigma?

Are you the person they refused to allow in?

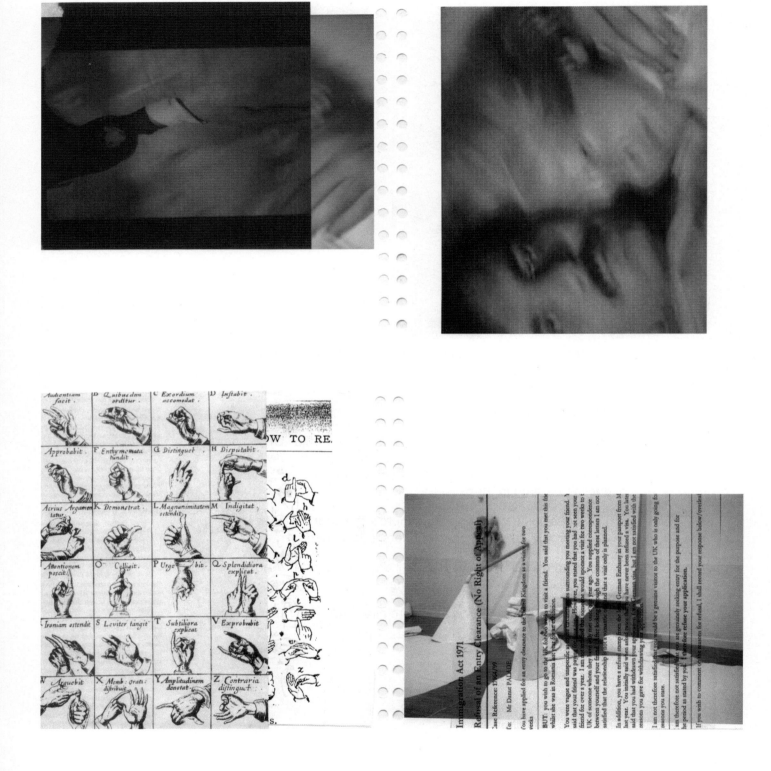

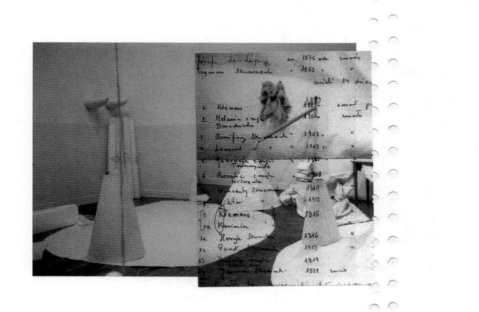

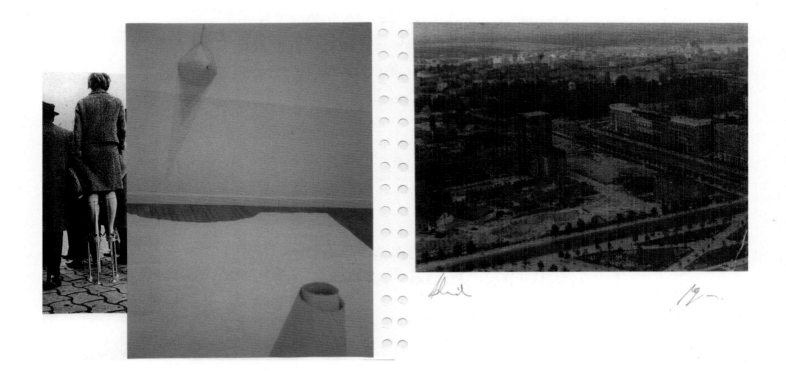

Exclusion

Soudain au milieu de ces fragments de
vies, deux pages de signes, et quels signes!
[A main gauche un alphabet des signes
pour les non-entendants, vingt-quatre expressions
des mains, des doigts, - qui s'adressent à
la personne à qui le sort a refusé l'entrée dans
la parole et le son.
[A droite le refus signifié au demandeur d'asile
le verdict, la version temps modernes du
"Tu n'entreras pas dans la Terre Promise".
[Ce livre serait donc le mémorial de l'Immigré
Inconnu?
[Les mots de refus sont si lourds, si implacables
que le formulaire en est tombé sur le côté.
Cette guillotine a tranché des destins de millions
de fugitifs dans notre vingtième siècle parcouru
d'exilés -
[Immigration Act 1971
[Refusal of an Entry Clearance
[No right of appeal
[Arbeit macht frei
[Vous qui frappez ici, abandonnez toute espérance
Violence glacée des phrases, hargne inhumaine
[des arrêts de vie -

## Exclusion

Suddenly in the middle of these life fragments, two pages of signs, and what signs!

On my left hand an alphabet of signs for the non-hearing, twenty-four expressions for hands, fingers, addressed to the person to whom fate has refused entry to word and sound.

On the right the refusal meant for the asylum seeker, the verdict, modern-day version of "You will not enter the Promised Land".

Will this book be the memorial to the Unknown Immigrant then?

The words of refusal are so heavy, so implacable that the form has fallen on its side. This guillotine has severed the destinies of millions of fugitives in our twentieth century teeming with exiles.

Immigration Act 1971

Refusal of an Entry Clearance

No right of appeal

*Arbeit macht frei*

You who knocks here, abandons all hope

Frozen violence of phrases, inhuman spite lives cut short

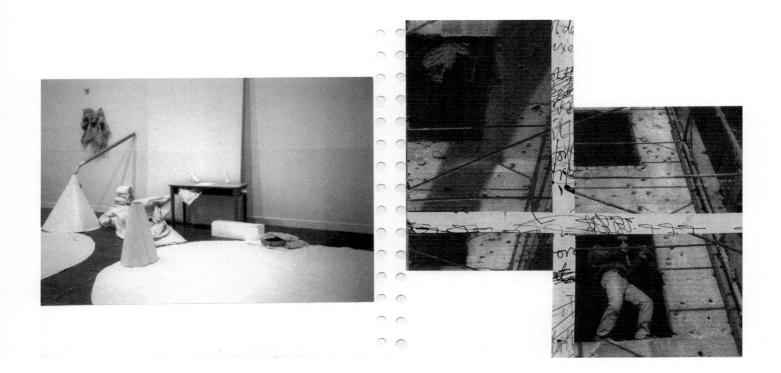

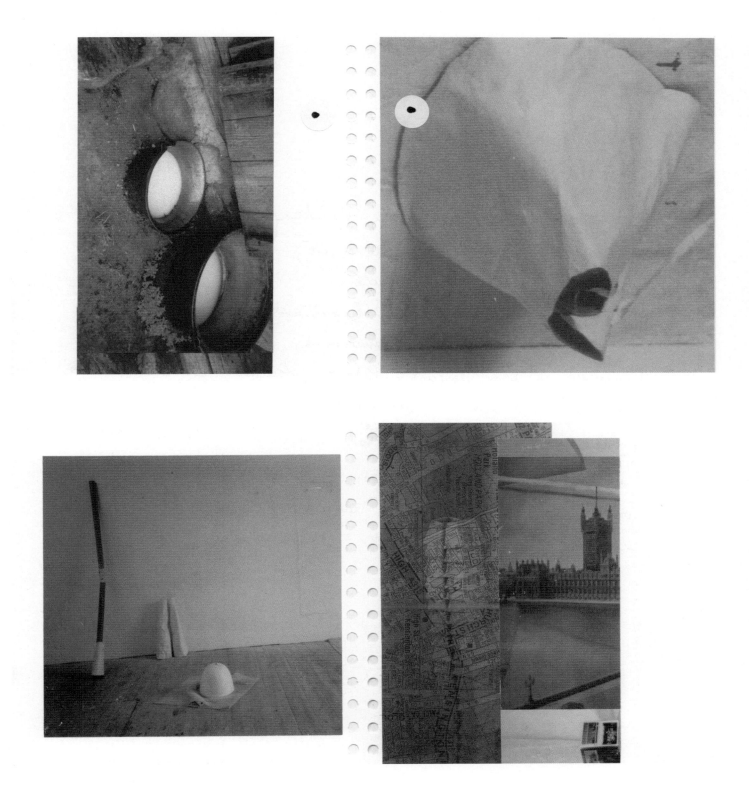

[ La paix des objets, si peu de temps après l'explosion
A la place -de l'acte de rejet, deux écuelles de
lait, -couchées sur le coté.
[ Comme une pensée d'hospitalité -
[ -Et pourtant, -aux environs, aucun chats?
[ Comme si l'on devait lire : même . chats interdits
ou Interdit même aux chats.
[ Alors les écuelles pleines seraient abandonnées
et derrière ces images qui éveillent le regret
on craindrait quelque catastrophe récente,
-comme -un Tchernobyl.

The peace of objects, so little time after the eviction. Instead of the act of rejection, two milk bowls, lying on the side.

Like a thought of hospitality.

And yet, in the vicinity, no cat?

As if we must read: cats not permitted or No Entry even to cats.

So the full bowls will be abandoned and behind these images that arouse regret we'd fear some recent catastrophe, like Chernobyl.

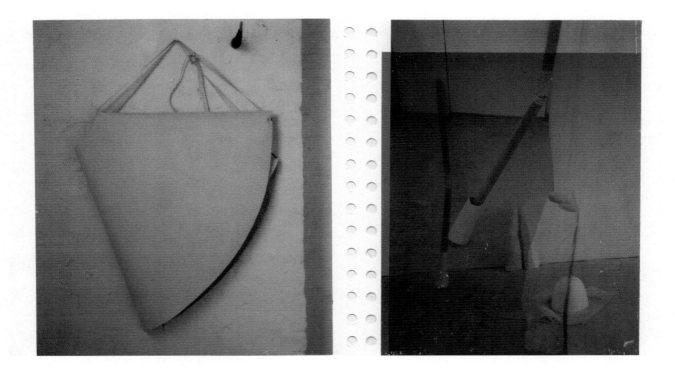
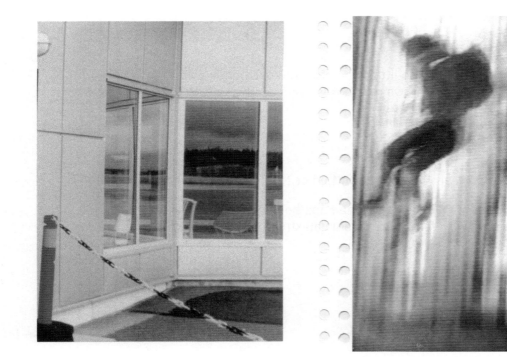

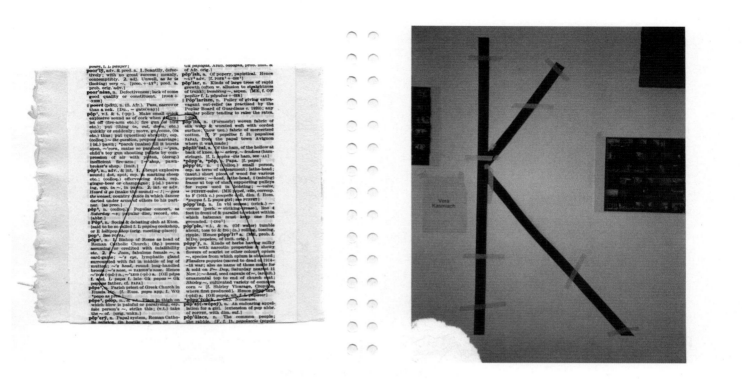

Alors qui passait, qui ne passait pas ?

Serait - ce   P. ?    Ou K ?

Est-ce une Réponse ?    les lettres qui se montrent, mais
déguisées, ces lettres initiales qui bégaient
sur une page, sur un mur ?
On dirait une signature secrète.
C'est un nom qui aurait commencé par P dans
une autre vie, ou par K, à Prague peut être ?
Et par la suite la lettre aurait été blessée,
puis arrêtée, détenue, retenue -captive d'un mur
par des liens adhésifs. C'est qu'elle avait
donné des signes de début de fuite,
elle avait esquissé un pas, allongé une jambe,
annoncé le chemin.

So who goes, who doesn't go?

Would it be P.? Or K?

Is it an Answer? These letters that show themselves, but disguised, these initials that stammer on a page, on a wall?

We'd say a secret signature.

It's a name that would have begun with P in another life, or K, perhaps in Prague?

And then the letter would have been injured, stopped, detained, held captive by a wall of sticky ties. It's because it gave signs of wanting to flee, it had sketched a step, stretched out a leg, announced a path.

– Stop! Halt! Tu n'iras pas plus loin, K.!

– Mais voyez l'art de la mise en scène : ce sont justement les entraves qui témoignent de l'âme inspirée de cette lettre. Une lettre? Un chiffre – Celui de l'artiste qui habite au fond de la chambre mentale de Maria, l'autre au secret. Sur la plaque de son absence de maison on peut lire son "vrai" nom : Vera Kasmiach. Vera Kasmiach ou Maria Chevska en vérité –

x x

– Nous sommes toujours au moins deux dans le même corps et dans la même histoire, comme on le sait depuis le premier trait d'Archimède sur la sable. Comme Kafka nous le rappelle : nous êtres humains à deux âmes rivales, êtres à deux âmes qui s'attaquent l'une l'autre, êtres dissociés et disloqués

Stop! Halt! You'll go no further, K.!

But look at the art of staging: it's precisely the constraints that testify to the inspired soul of this letter. A letter? A number. That of the artist who lives at the bottom of Maria's mental room, the other in secret. On the slab of her absence of house we can read her "true" name: Vera Kasmiach. Vera Kasmiach or Maria Chevska in truth.

We are always at least two in the same body and the same story. As we know since Archimedes' first line in the sand. As Kafka reminds us: we are human beings with two rival hands, beings with two souls that attack each other, beings broken up and dislocated

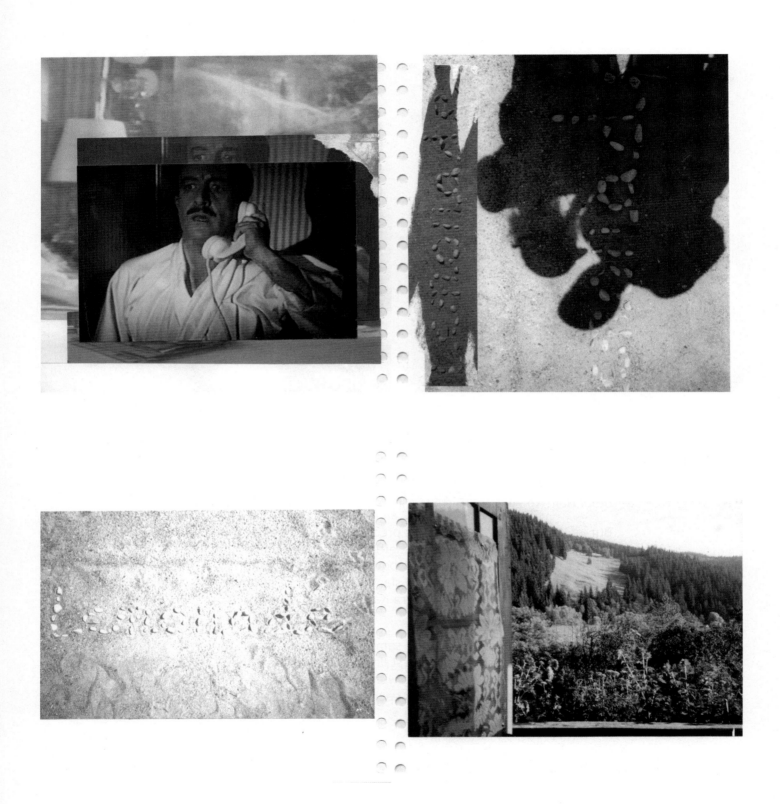

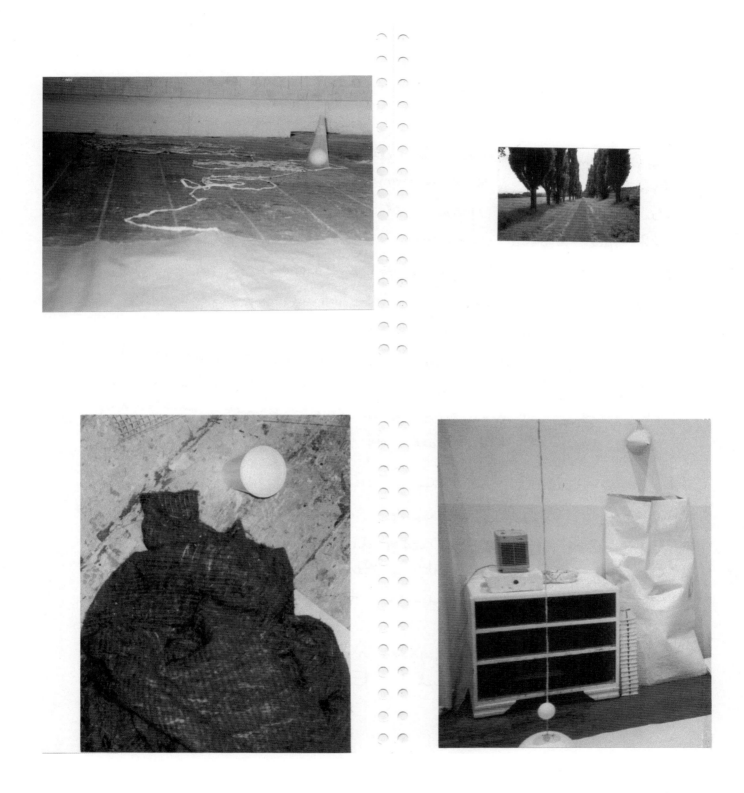

On ne comprendra rien à cette archive tremblante, *Mémoire,* troublée sans se remémorer l'histoire des guerres du siècle à peine passé, et surtout l'histoire de celle que l'on a nommée <u>la deuxième</u> guerre mondiale la guerre qui se souvient de la Première et qui annonce la Troisième, la charnière entre les deux pages du siècle.

Quelqu'un ici, dans cet album, se souvient et oublie, oublie et cherche à reconstituer l'existence et ~~d'un être~~ l'<u>exécution</u> d'un être, figure emblématique de ces temps faucheurs de la durée vitale.

Qui se souvient de qui ?

Est-ce le condamné à mort qui se souvient deux pages plus tard de ces deux maisons dans la brume ? Ou bien sont-ce les deux maisons qui se souviennent dans la brume de celui qui les vivait naguère ?

Ou bien les deux maisons vivantes pensent elles à la mort qui les attend ? Elles et le jeune homme aux yeux bandés ?

## Memories

We will understand nothing from this trembling, troubled archive, without recollecting the history of war in the century scarcely past, and especially the history of the one we have called the second world war, the war that remembered the First and announces the Third, the hinge between the two pages of the century.

Someone here, in this album, remembers and forgets, remembers and forgets to reconstruct the existence and the execution of a being, emblematic figure of these times slashed from the vital term.

Who remembers whom?

Is it the one condemned to death who remembers two pages later these two houses in the mist? Or are they the two houses that remember in the mist the one who lived there before?

Or do the two living houses think of the death that awaits them? They and the young man with his eyes bound?

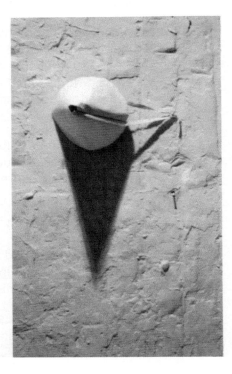

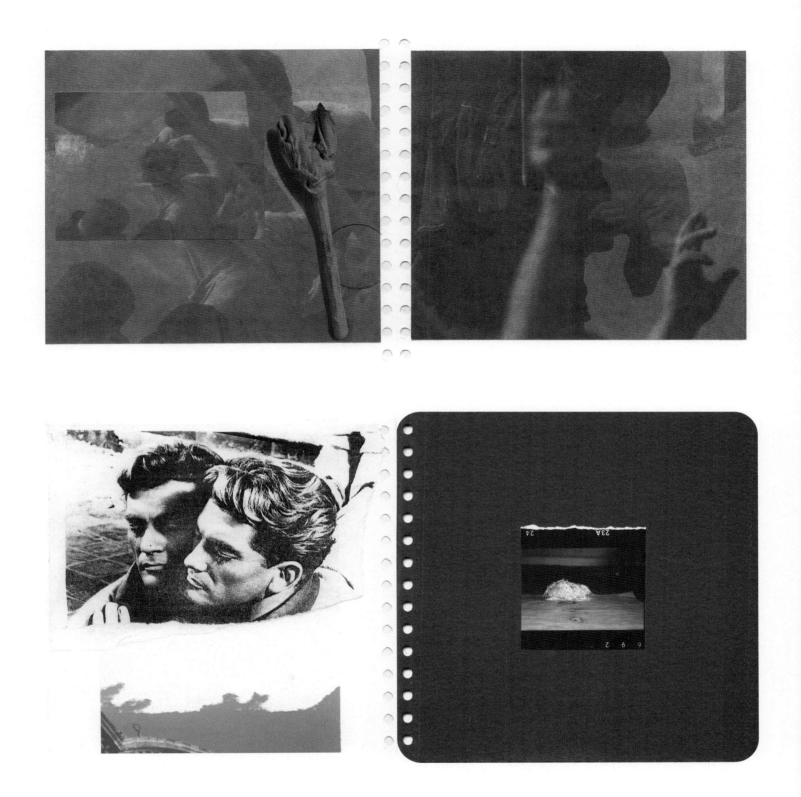

Bandeau : encore un tissu.
(Il faut lire ce livre, le regarde, s'en souvient,
les yeux bandés, le déchiffrer à travers les
lambeaux d'oubli qui le voilent.

Blindfold: another cloth.
You have to read this book, look at it, remember it, with bound
eyes, decipher it through the scraps of oblivion that veil it.

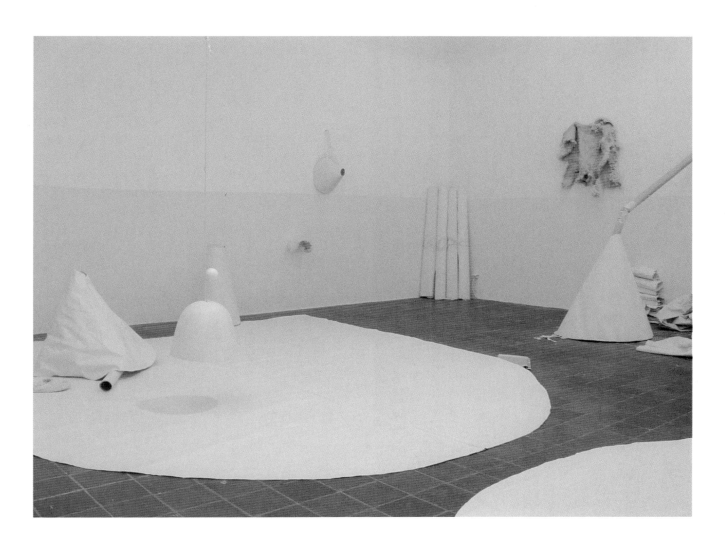

COMPANY

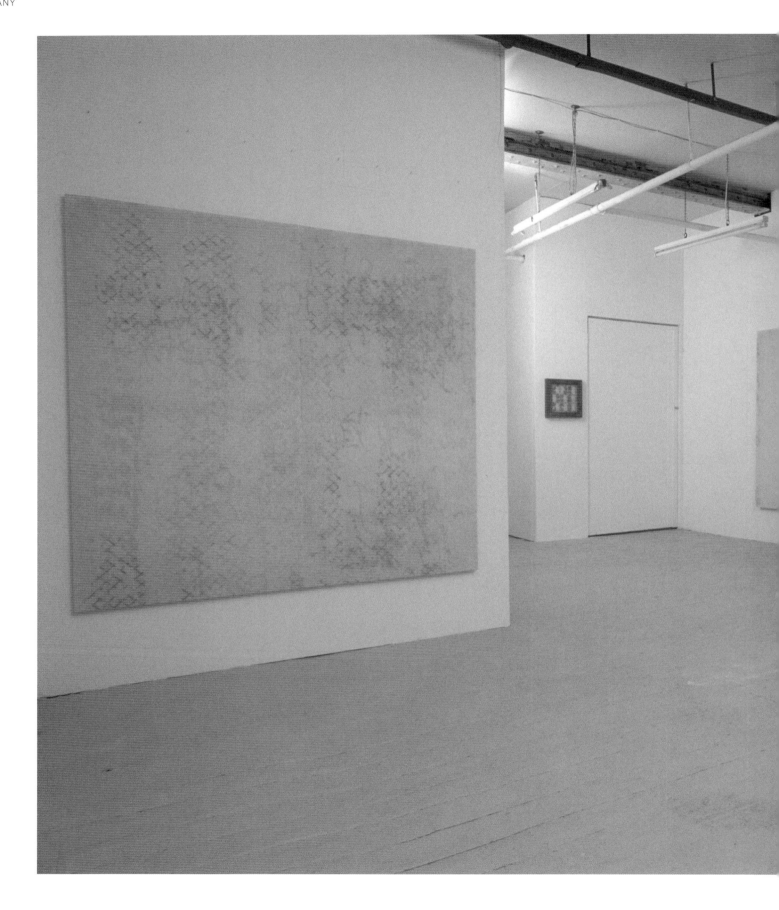

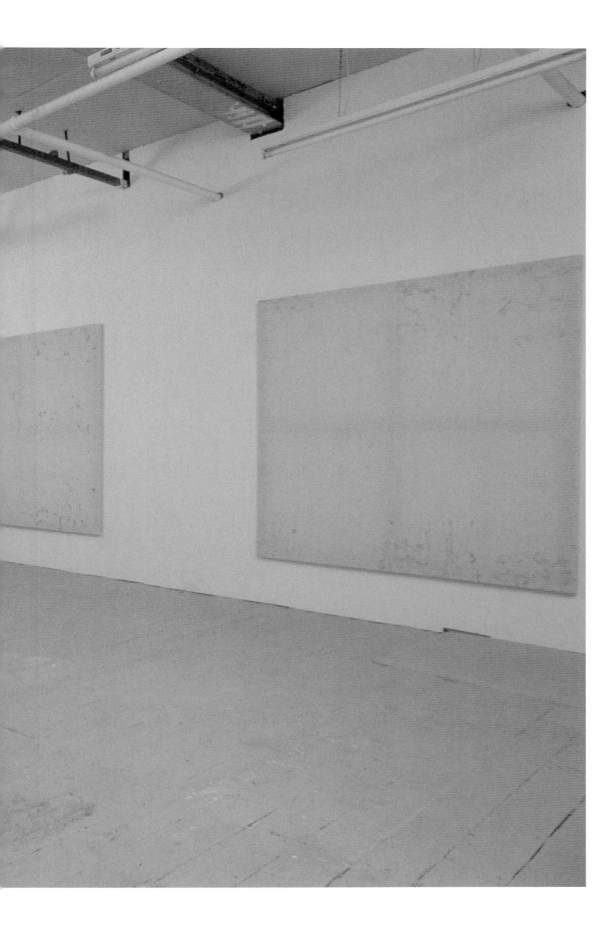

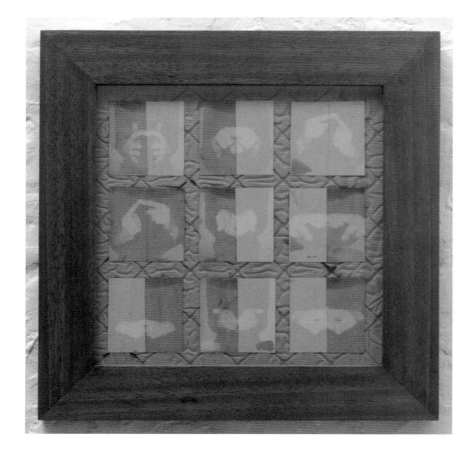

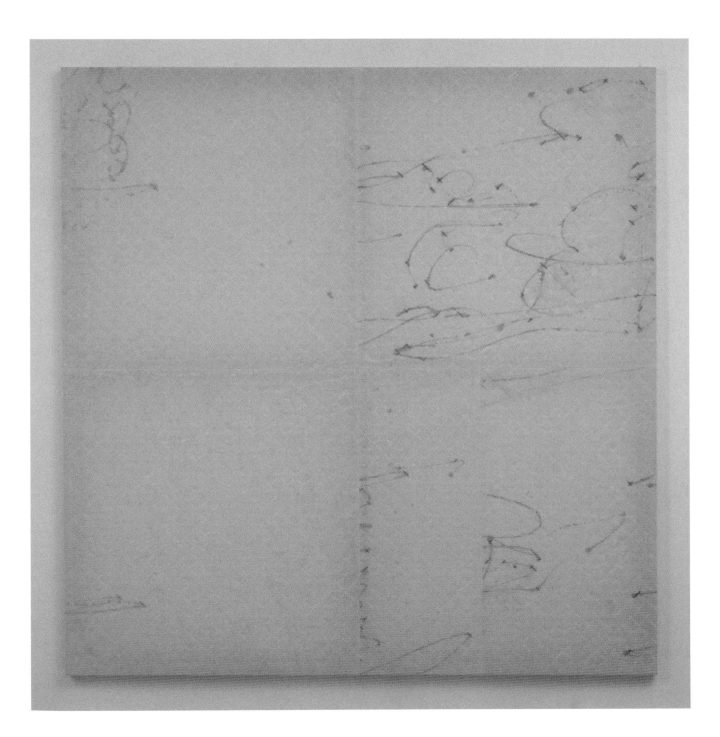

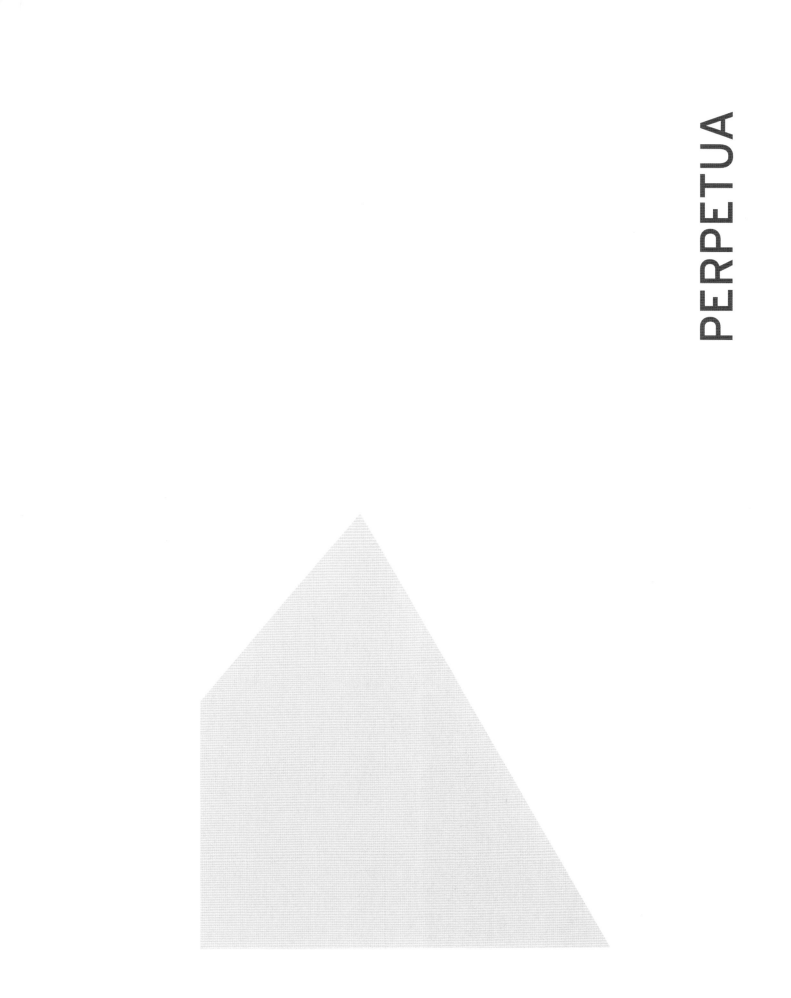

PERPETUA

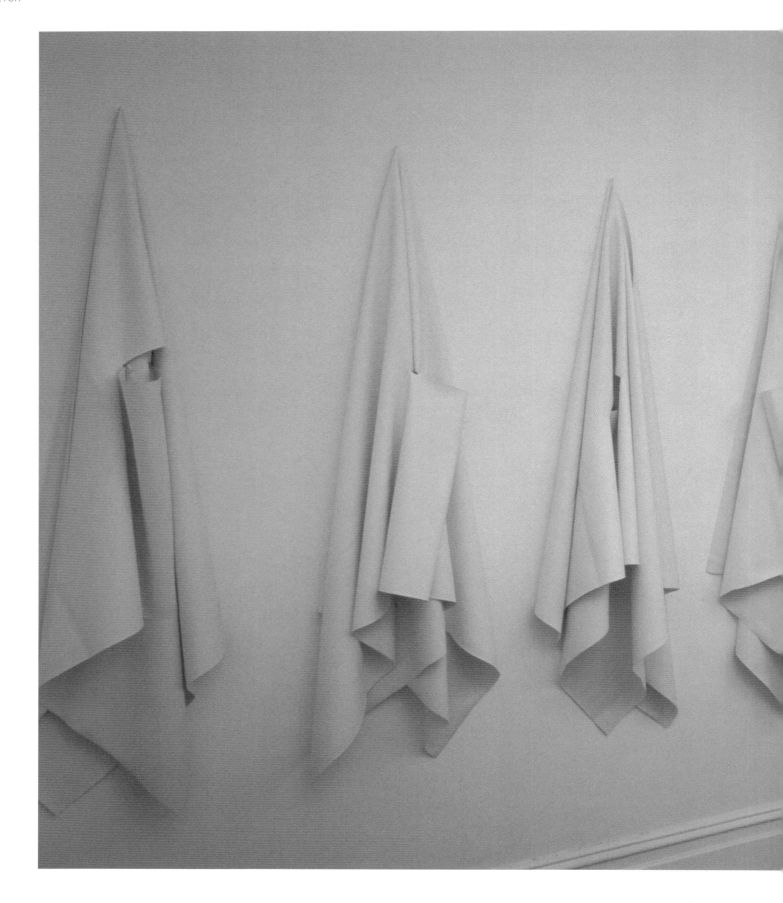

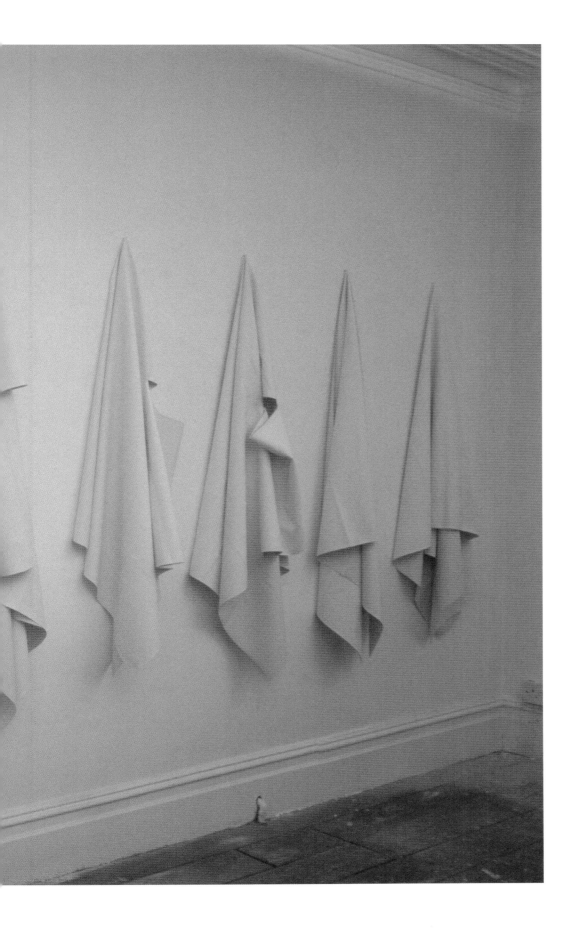

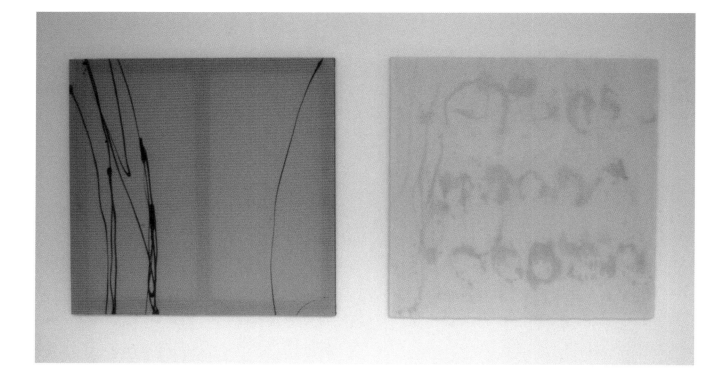

WEIGHT

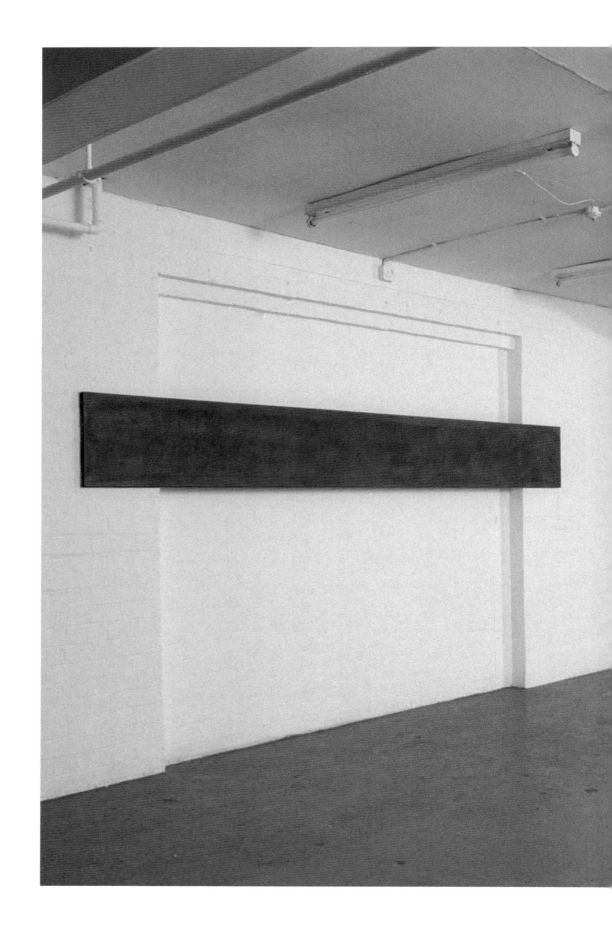

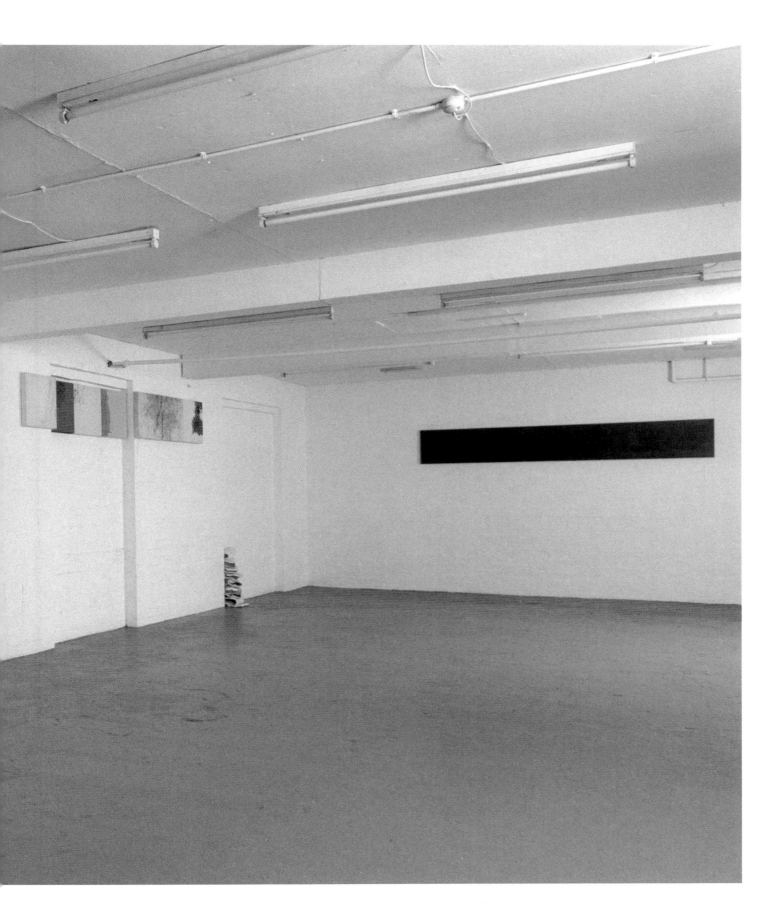

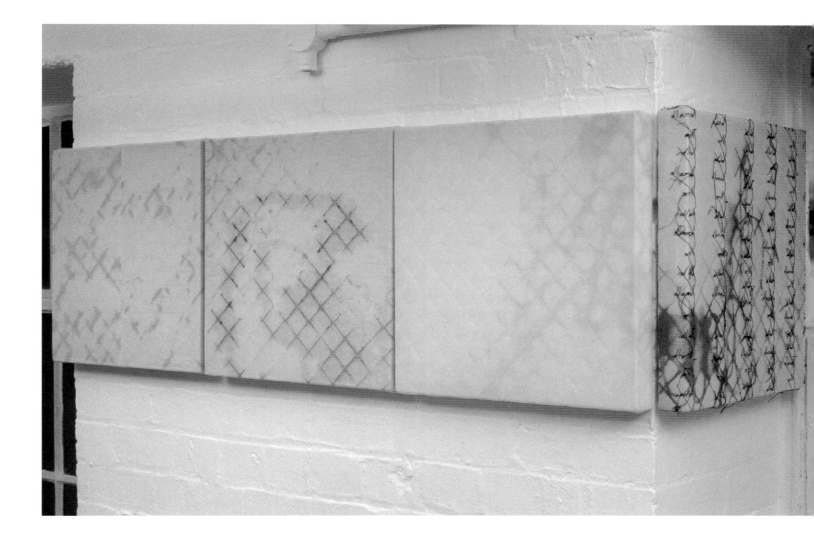

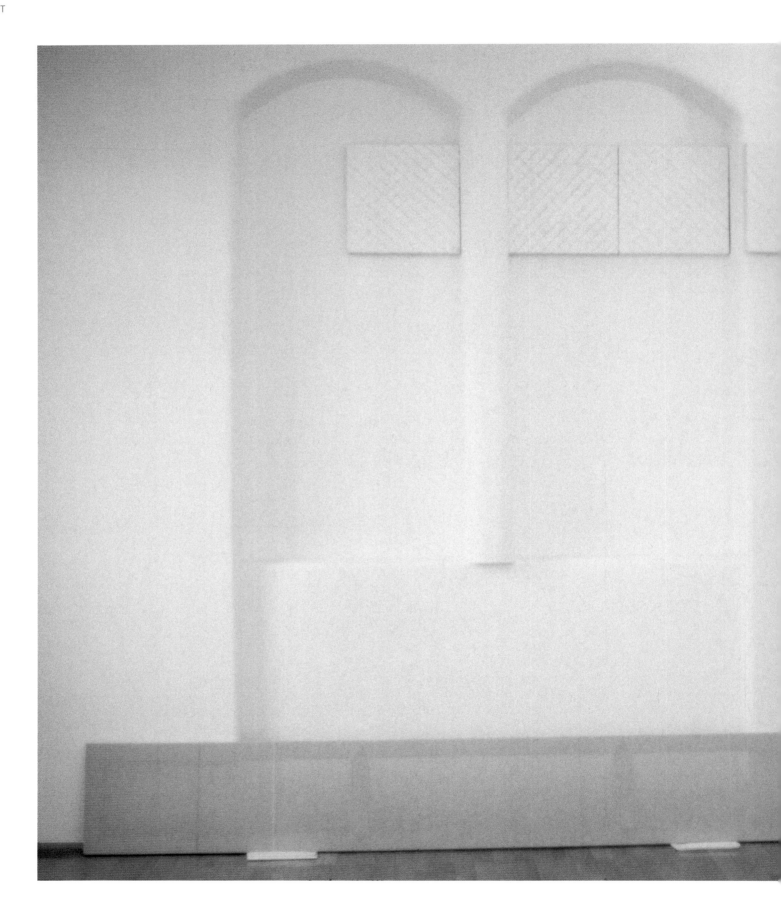

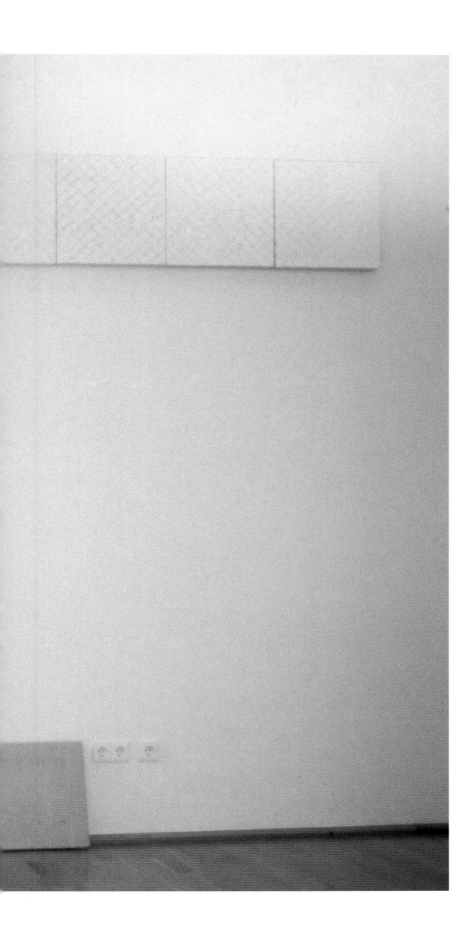

VISIBILITY

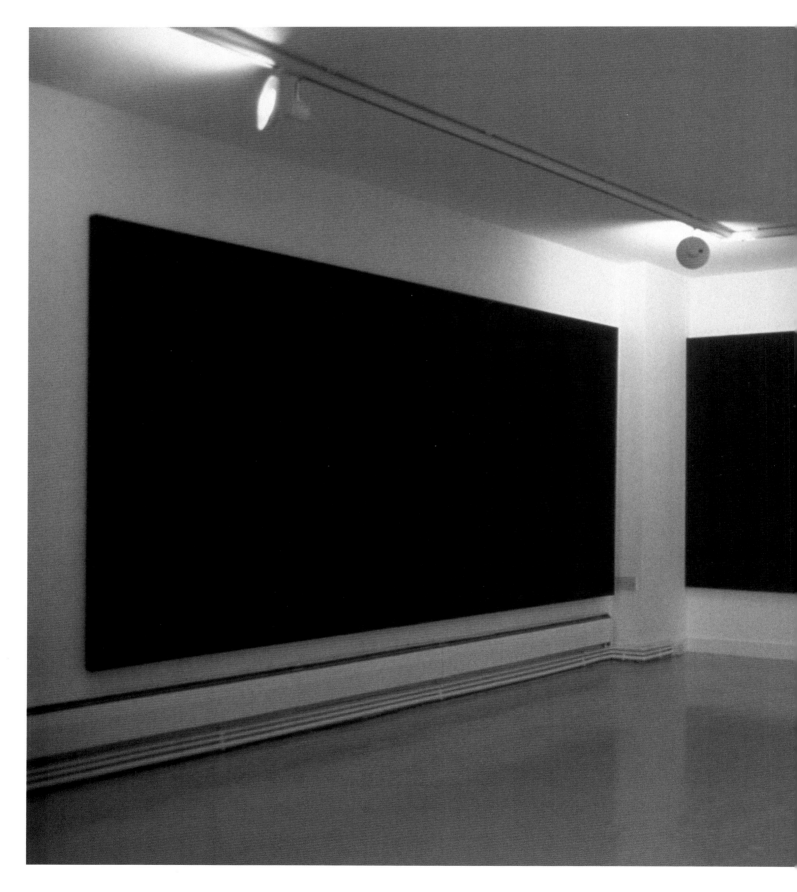

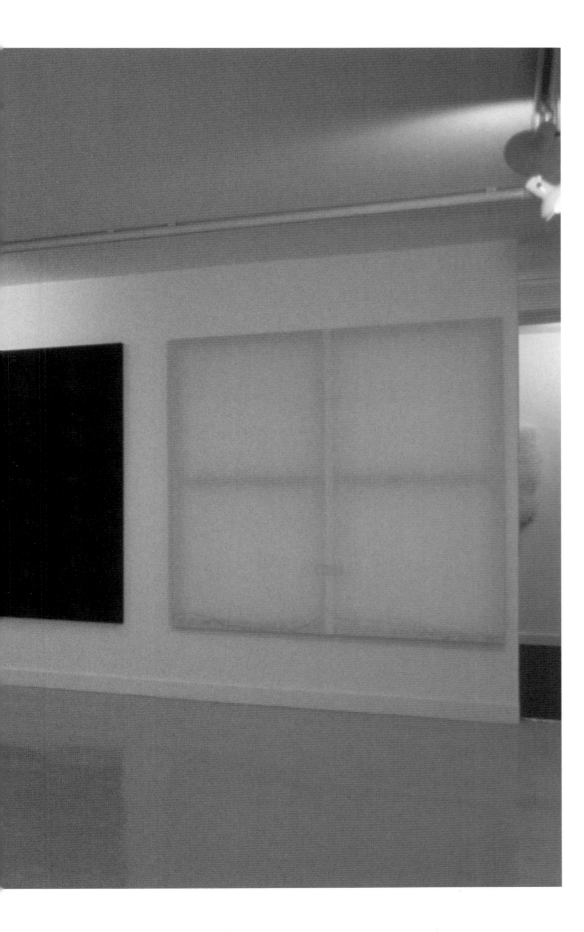

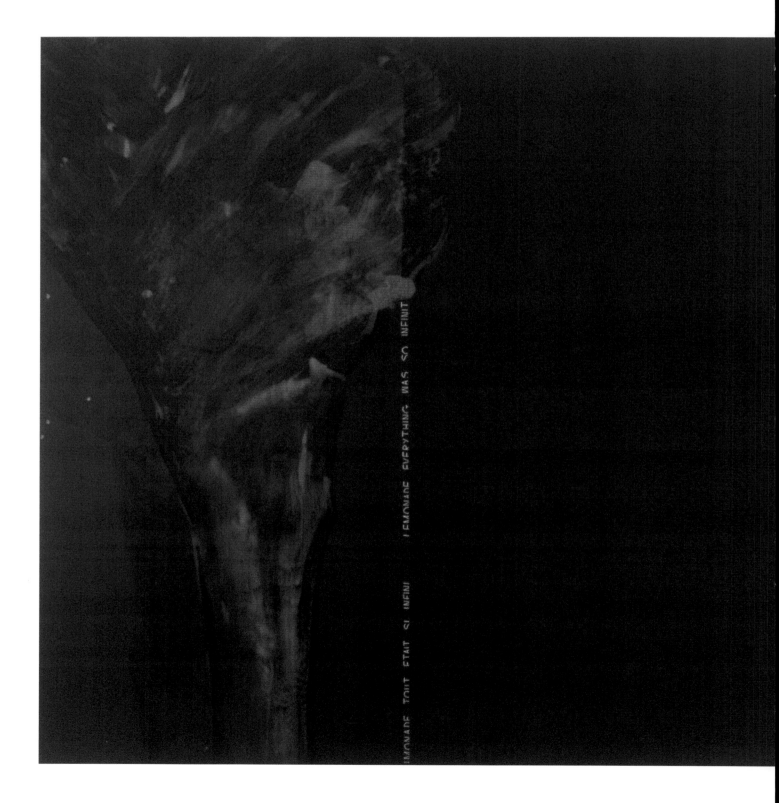

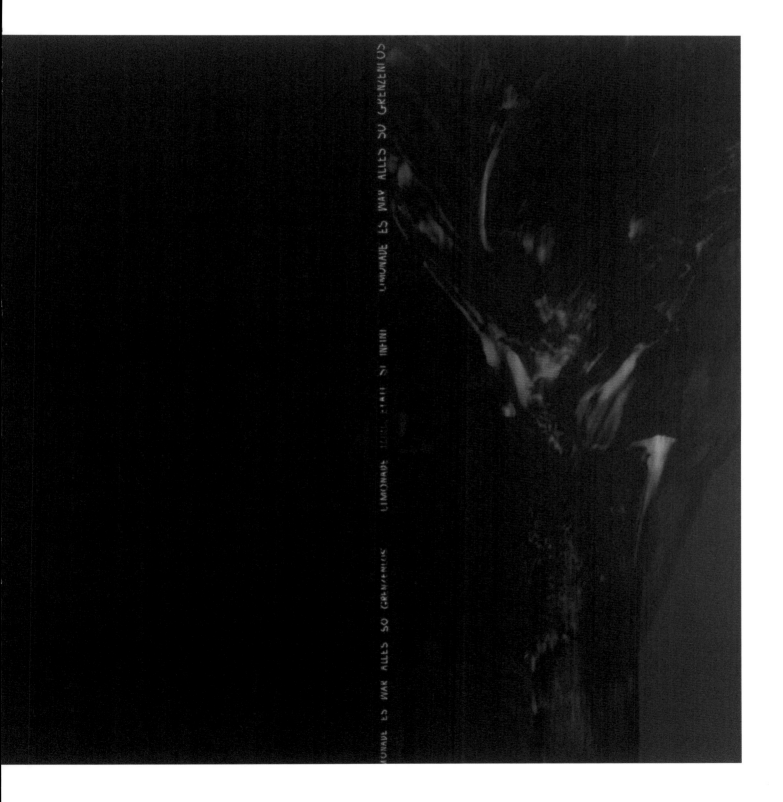

## MARIA CHEVSKA

Born in England
Lives and works in London

### SELECTED SOLO EXHIBITIONS

2005    *[Who is refused]*, Slought Foundation, Philadelphia, USA
Reading Room, Moca London, UK

2004    *Can't Wait [letters RL]*, Andrew Mummery Gallery,
London, UK

2003    *Vera's Room*, Kunstpunkt, Berlin, Germany
Galerie Philippe Casini, Paris, France
Maison des Arts de Bagneux, France
Artotheque, Caen, France

2002    Galerie Philippe Casini, Paris, France
*Eh*, Maison de la Culture d'Amiens, Amiens, France
Wetterling Gallery, Stockholm, Sweden

2001    *Why Don't You*, Andrew Mummery Gallery, London, UK

2000    Galerie Philippe Casini, Paris, France
Company, Watertoren Galerie and W3 Galerie,
Vlissingen, The Netherlands
*Put Yourself in my Shoes*, Maze Galerie, Turin, Italy

1999    Abbot Hall Art Gallery and Museum, Cumbria, UK
*Eyeballing*, Andrew Mummery Gallery, London, UK

1997    Spoken Image, Museum Goch, Germany
Perpetua, Gallery Awangarda BWA, Wroclaw, Poland
*Spoken Image*, Kunstmuseum Heidenheim, Germany

1996    *Weight*, Andrew Mummery Gallery, London, UK

1994    Anderson O'Day Gallery, London, UK
*Perpetua*, Angel Row Gallery, Nottingham, UK

1993    The Warehouse Gallery, Amsterdam, The Netherlands

1992    Anderson O'Day Gallery, London, UK

1991    Art Frankfurt, Germany

1990    Brasenose College, Oxford, UK
*Visibility*, Anderson O'Day Gallery, London, UK

1989    Anderson O'Day Gallery, London, UK

1987    Bernard Jacobson Gallery, London, UK

1986    Chapter Arts, Cardiff, Wales
Mario Fletcha Gallery, London, UK

1985    Midland Group, Nottingham, UK

1982    Air Gallery, London, UK

### SELECTED GROUP EXHIBITIONS

2005    Lekker, APT Gallery, London

2004    *Quand j'en trouve j'en mets a la carte*, Galerie Philippe
Casini, Paris, France

2003    *20 x 5 Drawings*, The Eagle Gallery, London, UK
*Translater's Notes*, Cafe Gallery Projects, London, UK
*Independence*, South London, London, UK

2002    *Peintures*, Rennes, France
Stoff Malerie, Plastik Installation, Städtische Galerie,
Albstadt, and Kunsthaus Kaufbeuren, Germany
*De Singuliers Debordements*, Maison de la Culture,
Amiens, France
*Fluent*, Centenary Gallery, London, UK

2001    Marianne Hollenbach Gallery, Stuttgart, Germany
*La lune sur le pont, un masque bleu*, Galerie Philippe
Casini, Paris, France

2000    *Oeuvres d'etre*, Temple University, Rome, Italy
*Cultural Ties*, Jariwala Westzone Gallery, London, UK
*Nouvelles Peintures*, Galerie Phillipe Casini, Paris, France
T*he Wreck of Hope*, The Nunnery Gallery, London, UK,
*Movin' on up*, Andrew Mummery Gallery, London, UK

1999    Chora, Underwood Street, London, UK
Bath, Bracknell, Abbot Hall, UK
Hoxton New Music Collaborations, London, UK

1998    Tescani Residency, Bacau Museum of Art, Romania
*Places: Works from the NatWest Collection*, Lothbury
Gallery, London, UK

1997    *Prescencing*, Eagle Gallery, London, UK
Artoll Lyrik Tage, Cologne, Germany
*Lemonade*, Andrew Mummery Gallery, London, UK

1996    *Andata e Ritorno*, British Artists in Italy 1980-1996,
Spacex Gallery, and City Museum, Exeter, UK
*Permission to Speak*, Worcester City Museum and Art
Gallery, UK

1995    *White Out*, Curwen Gallery, London, UK
*New Painting*, Darlington Arts Centre,
Newcastle-upon-Tyne, UK

1994    *Identita e Rappresentazione Cartografico*, Museo Pigorini,
Rome, Italy
*Mostre*, British School at Rome, Italy

1993    *Four Artists*, Anderson O'Day Gallery, London, UK
*Paintings from the Arts Council Collection*, Royal Festival
Hall, London, UK

1992    *The Discerning Eye*, Mall Galleries, London, UK
Whitechapel Open, Whitechapel Art Gallery, London, UK

1991    *Crossover*, Anderson O'Day Gallery, London, UK

1990    *The Theory and Practice of the Small Painting*, Anderson
O'Day Gallery, London, UK
*XXII International Festival of Painting*, Chateau Musée
Grimaldi, France

1986    *Four Painters*, City of London, UK Guildhall, London, UK

1985    *Retrospective*, Air Gallery, London, UK

1984    *Landscape, Memory and Desire*, Serpentine Gallery,
London, UK
Four Painters, Riverside Studios, London, UK

1984    *New Images: Printmaking*, Blond Fine Art, London, UK

1983    *New Blood on Paper*, Museum of Modern Art, Oxford, UK

1983-89 *Whitechapel Open*, Whitechapel Gallery, London, UK

1982    *The London Group*, Camden Art Centre, London, UK
*British Drawing*, Hayward Gallery, London, UK

1981    *Art and the Sea*, John Hansard Gallery, Southampton, and
ICA London, UK

### AWARDS

2002/5  British Council

2004    Arts Council England
Residency at Saint-Leger Centre D'Art Contemporain,
France

1998    Bursary, Tescani Cultural Centre, Romania, and
British Council

1994    Austin Abbey Award, British School, Rome, Italy

1984/79 Greater London Arts Association, UK

1982    Gulbenkian Foundation "Printmakers Award"

1977    Arts Council of Great Britain

## SELECTED COLLECTIONS

Museum of Bacau, Romania

Royal Bank of Scotland Group Art Collection

New Hall College, Cambridge

Kunstmuseum Heidenheim, Germany

Herbert Smith

Morgan Stanley

Ernst & Young

Glaxo Holdings

Oldham Art Gallery

Brasenose College, Oxford

Bolton City Art Gallery

WorldBank

British Council

Gulbenkian Foundation

Arts Council of England

Contemporary Art Society

## SELECTED BIBLIOGRAPHY

**2005**   Kierkuc-Bielinski, Jerzy, *Reading as Revolution*, London: MOCA

**2004**   Geldard, Rebecca, "Can't Wait", review , *Time Out*, April

**2003**   Hubbard, Sue, "20 x 5 Drawings", review, *The Independent*, November
Alexandre, Xavier, "Les jours d'écriture de Maria Chevska", *Ouest*
Dagen, Philippe, review, *Le Monde*, February

**2002**   Mertens, Veronika, "Der Vorhang ist das Bild", in *Stoff: Malerei, Plastik, Installationen*, edited by Veronika Mertens *et al*, Albstadt: Städtische Galerie
Grasser, Olivier, *De Singuliers Debordements*, exhibtion cat, Amiens: Maison de la Culture
Malmber, Carl-Johan, "Maria Chevska", *Contemporary*, November
Godefroy, Raymond, "Le Corps de Lamante", *Le Journal*, January/February
Piguet, Philippe, "Le Mot et L'image", *L'oeil*, February/March, No 533
Hindry, Ann, "Interweaving Language: the work of Maria Chevska" in *Eh*, exhibition cat, Amiens

**2001**   O'Reilly, Sally, "Why Don't You", review, *Time Out*
Hubbard, Sue, "Why Don't You", review, *Independent on Sunday*
Gisbourne, Mark, "Memory Matters", *Art Review*, April
Garulli, Lavinia, "Oeuvres D'etre", *Arte Critica*

**2000**   Gambari, Olga, "Put Yourself In My Shoes", *La Repubblica*
Dagen, Philippe, "Langages, code, dérèglement", *Le Monde*, April
Stoddart, Hugh, "Chora", *Contemporary Visual Arts*, No 26

**1999**   Hubbard, Sue, *Chora*, exhibition cat, Underwood Street Gallery: London
Charlotte Mullins, "Chora", *Independent on Sunday*, September
Godfrey Tony, "I Am About To Tell You A Story", in *Company*, exhibition cat, Kendal: Abbot Hall Gallery
Morley, Simon, "The Painted Word", *Contemporary Visual Arts*, June
Martin Coomer, "Maria Chevska", Time Out, April/May

**1998**   Morley, Simon, "Presencing", review, *Untitled*
Hubbard, Sue, "Out of the Void", *Contemporary Visual Arts*, No 17

**1997**   Martin Holman, *Presencing*, exhibition cat, London: Eagle Gallery, November
Gisbourne, Mark, "Maria Chevska", *Untitled*
Hirner, Renè and Jörg Becker, *Spoken Image*, exhibition cat, Heidenheim: Kunstmuseum Heidenheim

**1996**   Craddock, Sacha, "Maria Chevska: Weight", review, *The Times*, November
Hubbard, Sue, "Maria Chevska: Weight", review, *Time Out*, November

**1996**   Pollock, Griselda and Marina Warner, *Women's Art*, Cambridge: New Hall

**1995**   Guha, Tania, "White Out", *Time Out*, review, November

**1994**   Morley, Simon, "Maria Chevska", review, *Art Monthly*
Archer, Michael, *Perpetua*, exhibition cat, Nottingham: Angel Row Gallery
Bryden, Mary "Maria Chevska and Hélène Cixous", *Word and Image*

**1993**   Kent, Sarah, "Hanging Matter", review, *Time Out*, May
Godfrey, Tony, "Maria Chevska", review, *Art in America*, April

**1992**   McEwan, John, "Maria Chevska", review, Sunday Telegraph, October
Norrie, Jane, "Maria Chevska", review, *Arts Review*, November
Morley, Simon, "Visibility", *Art Monthly*, November
Hubbard, Sue, "Maria Chevska", *Time Out*, November
Hilty Greg, *Reading Matter*, exhibition cat, London: Anderson O'Day Gallery

**1991**   Fortnum, Rebecca, "Double Speak: Maria Chevska's Diptychs", *Women's Art Magazine*

**1990**   McEwan, John, "Postcards from the Edge", *The Sunday Telegraph*, November
Taylor, John Russell, "Cut and Dried Assembly", *The Times*, November
Vaizey, Marina, "Drawing out the Feminine", *The Sunday Times*, November

**1990**   Fortnum, Rebecca, "Figurative Fragments", *Oxford Today*, November/December
Beaumont, Mary-Rose, "Maria Chevska", *Arts Review*
Kent, Sarah, "Maria Chevska", *Time Out*
Harrod, Tanya, "Down an Old Familiar Road to the Discovery of the New", *Independent on Sunday*, October
Renton, Andrew, *Maria Chevska*, exhibition cat, London: Anderson O'Day Gallery

**1989**   Renton, Andrew, "Maria Chevska", review, *Flash Art*
Vaizey, Marina, "A Brush with Experience", *The Sunday Times Magazine*

**1988**   Beckett, Sister Wendy ed, *Contemporary Women Artists*, Oxford: Phaidon Press

**1987**   Beaumont, Mary-Rose, "Maria Chevska", *Arts Review*, March

**1986**   Briers, David, "Maria Chevska", *Arts Review*, July

**1985**   Bonshek, Anna, "Feminist Romantic Painting: A Re-Constellation", *Artist's Newsletter*
Ayers, Robert, *Maria Chevska*, exhibition cat, Nottingham: Midland Group Gallery

**1984**   Godfrey, Tony, *Landscape, Memory, and Desire*, exhibition cat, London: Serpentine Gallery

# ACKNOWLEDGMENTS

This publication was made possible with the generous finalcial support of the following organisations: Arts Council of England; Andrew Mummery Gallery, London; Galerie Philippe Casini, Paris; Parc Saint Leger, Centre D'Art Contemporain de Pougues-les-eaux (with the help of the Le Conseil Général de la Nièvre, le Ministère de la Culture et de la Communication Direction Régionale des Affaires Culturelles de Bourgogne, le Conseil Régional de Bourgogne, la Ville de Pougues-les-Eaux), and Wetterling Gallery, Stockholm.

Photography: MIchael Franke, Edward Woodman.

 **Black Dog Publishing**
Architecture Art Design Fashion History
Photography Theory and Things

Written by Tony Godfrey and Hélène Cixous
Designed by Emilia Gómez López @ Black Dog Publishing
Printed in the European Union

Black Dog Publishing Limited
Unit 4.04 Tea Building
56 Shoreditch High Street
London E1 6JJ

T +44 (0)207613 1922
F +44 (0)207613 1944
E info@bdp.demon.co.uk
www.bdpworld.com

British Library Cataloguing-in-Publication Date.
A catalogue record for this book is available from the
British Library.

ISBN 1 904772 29 3

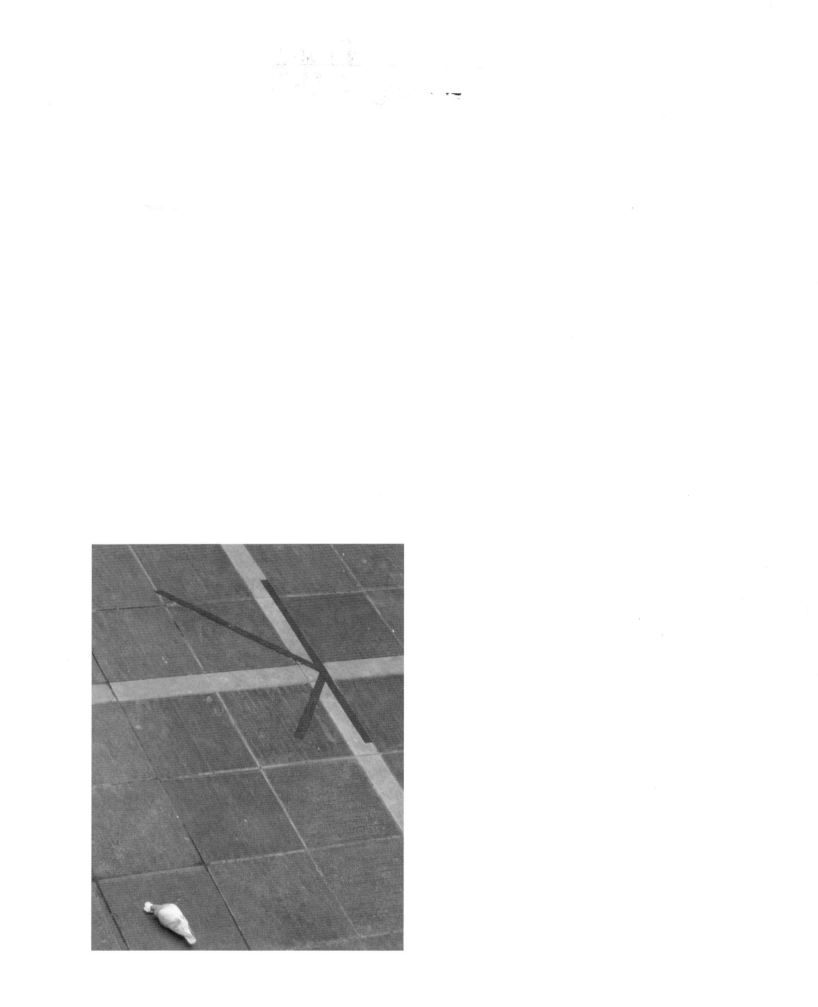